COLD WAR KENT

Clive Holden

AMBERLEY

Acknowledgements

This book could not have been written without the help and encouragement of several people. Special thanks must go to Victor Smith for allowing me to use his work on the Civil Defence organisation and the Gravesend 'Cold War' bunker as a basis for one of the chapters.

I am also very grateful to the following individuals for allowing me to reproduce their photographs: Victor Smith, Steve Tanner, Barry Stewart and Nick Catford.

First published 2021

Amberley Publishing
The Hill, Stroud
Gloucestershire, GL5 4EP

www.amberley-books.com

Copyright © Clive Holden, 2021

The right of Clive Holden to be identified as the Author of this work has been asserted in accordance with the Copyrights, Designs and Patents Act 1988.

ISBN 978 1 4456 9541 9 (print)
ISBN 978 1 4456 9542 6 (ebook)

British Library Cataloguing in Publication Data.
A catalogue record for this book is available from the British Library.

Typesetting by SJmagic DESIGN SERVICES, India.
Printed in Great Britain.

Contents

Introduction

By the end of the Second World War, in September 1945, the United States was the world's dominant military power. The Soviet Union, with its huge conventional forces, was in occupation of most of central and eastern Europe and was already denying those countries the right to determine their own destinies by supporting communist take-overs of their governments. But it was the USA that was in sole possession of the atomic bomb and had proved its willingness to use it with its devastating strikes against the Japanese cities of Hiroshima and Nagasaki.

Relations between these two great powers with radically different political ideologies had already cooled before the end of the war and now tensions were rising as their forces faced each other in Europe.

Germany had been divided between East and West, with the Soviet Union in occupation of the east of the country while the USA together with its allies, Britain and France, each had Zones of Occupation in the west. The capital city, Berlin, was similarly divided. The USA and its allies were determined to prevent the spread of communism into Western Europe and to defend it from Soviet aggression.

On its part, the United Kingdom concluded defence pacts with France (1947) and the Benelux countries (1949), agreeing to come to their aid if they were invaded and to maintain a British presence in Germany for fifty years.

From 1947 President Truman had committed the United States to the containment of communist expansion, through what became known as the 'Truman Doctrine', and on 4 April 1949 along with the major Western European powers and Canada, signed the North Atlantic Treaty in Washington creating the North Atlantic Treaty Organisation (NATO), which committed the US to the defence of Europe.

The year 1949 also saw the Soviet Union test its first nuclear bomb and a year later its ally North Korea invaded South Korea which had the support of the United States and the other Western powers. The world stood on the edge of a dangerous precipice of a war with the two nuclear powers on opposing sides.

The United Kingdom now faced the threat of both conventional and nuclear bombing or missile strikes against its military, industrial, transport and communications infrastructure as well as its centres of population. The county of Kent contained many prime targets including Chatham Dockyard, the Grain oil terminal, several power stations, various army barracks, as well as the Channel ports which would be vital to the movement of military reinforcements to Europe.

In this book, I've sought to bring to the reader's attention several of the sites, some of which have been long forgotten, that played a vital part during the forty-five years of the 'Cold War'. The first part of the book consists of a brief overview of some of those

sites and the role they played in various aspects of the United Kingdom's preparations for a possible nuclear conflict. For the second part I have written slightly more detailed histories on seven other sites that had significant local importance during those years.

I do not claim this book to be a definitive history of Kent during this period of international tension but hope it will act as a reminder, to those of us that lived through it and for later generations, of how fortunate we were to have escaped experiencing the consequences of a global nuclear conflict.

Clive Holden
East Malling, Kent
September 2020

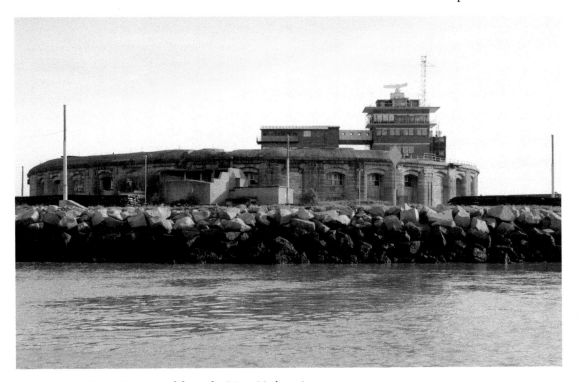

Garrison Point Fort viewed from the River Medway in 2015.

Part One: Radar, Communications and Airfields

The county of Kent had always been considered as 'Britain's Front Line County', due to its proximity to continental Europe, and it had certainly lived up to that role during the Second World War. The RAF fought much of the 'Battle of Britain' in the skies above the county while the coastal fortifications kept guard against the threat of a German invasion across the Channel. Later in the war, anti-aircraft guns based in Kent were the first line of defence against the V-1 flying bomb offensive.

By the end of the war in Europe in May 1945 most of Kent's defences had already been stood down but within a year tensions were rising between the Soviet Union and its wartime Western allies and events over the next few years would once more see the county facing the threat of possible air attacks on its industrial and population centres, and still numerous military installations.

After the end of the war the UK radar system had been rapidly run down. It was then envisaged that it would be at least another ten years before another major conflict and many UK radar stations had either been abandoned or placed on 'care and maintenance' footing.

Following the Berlin crisis of 1948, the first Soviet nuclear bomb test in 1949, and the outbreak of the Korean war one year later, improvements in the UK's air defences saw many wartime radar stations reactivated including the 'Chain Home' station RAF Dunkirk, near Faversham. The perceived threat was now of an onslaught of Soviet Tu-4 bombers armed with 20-kiloton yield atomic bombs. It was doubtful that, with the decayed state of the UK's air defences, they could have been detected and intercepted and in 1949 a government report recommended an urgent overhaul and improvement of the UK's air defences, under the codename ROTOR. The report recommended that the sprawling network of some 170 radar sites left over from the last war be rationalised and consolidated to sixty-six sites, and that the best existing radar be completely rebuilt to higher peacetime standards. RAF Dunkirk was one of fifteen stations selected under the Rotor programme as a 'readiness chain home' and its existing Type 1 radar was re-engineered as part of the first phase of the programme.

However, RAF Dunkirk's renaissance was short-lived. The introduction of the Type 80 radar into RAF service in early 1953 made the Dunkirk facilities redundant and the station was closed in 1955. The three wooden receiver towers were dismantled and sold for reuse elsewhere and then in 1959 three of the four transmitter towers were demolished. The fourth transmitter tower remained in RAF ownership and was used by the US Air Force throughout the Cold War period for microwave communications between the UK and NATO Headquarters in Paris and Brussels and bases in Western Europe. The surviving tower is now in private hands and space on it is leased to various telecommunications companies. Some of the other Second World War structures also survive on private land.

Above: The Second World War Transmitter Block at the former RAF Dunkirk.

Right: The surviving transmitter tower at the former RAF Dunkirk.

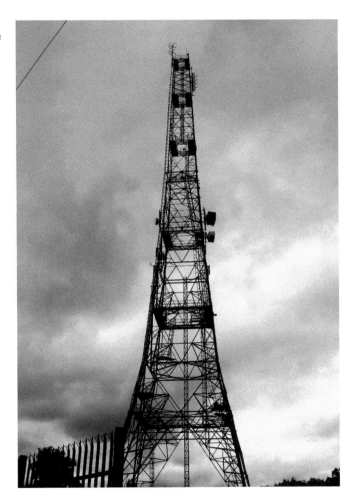

Another Kent wartime radar station, RAF Sandwich GCI (Ground Control Intercept) Station, remained in operation after the end of the war. Located on the south side of the Ash Road, in 1948 it was equipped with Type 7 and Type 21 radars.

In 1949 RAF Sandwich was selected to participate in the Rotor programme and the station was eventually relocated to Ash, 1.5 miles away to the south-west, where a new underground two-level operations room, known as a R3 bunker, was built. The bunker was constructed of reinforced concrete and designed to withstand 2,000lb bombs. The outer walls and roof of the Rotor operations blocks were 3 metres thick and the internal walls between 0.15 to 0.6 metres wide. The exterior was coated with an asphalt damp course and surrounded by a 0.15-metre brick wall.

Operations commenced at the new site in August 1954 and a new Type 7 radar was installed in October that year. A new camp was built to house the station's personnel adjacent to the former First World War 'Stonar Camp' on the south side of Ramsgate Road. 'Stonar House' was within the camp and was used for officers' accommodation. The peacetime establishment of Sandwich was to have total personnel of 370 comprising fifteen RAF officers, nine WRAF officers, 170 RAF other ranks, 174 WRAF other ranks and two civilians. In February 1953, the operational element of RAF Sandwich was retitled 491 Signals Unit.

The advent of faster jet bomber aircraft began to highlight serious deficiencies in parts of the Rotor programme. The manual control, reporting and filtering systems used to

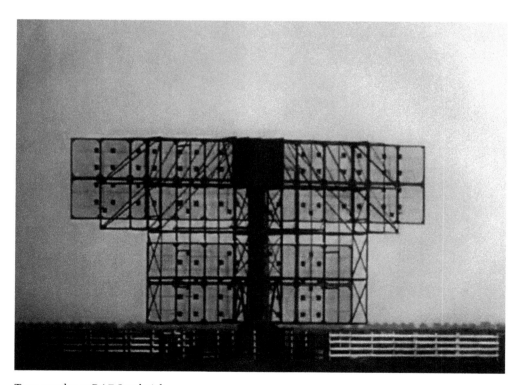

Type 7 radar at RAF Sandwich.

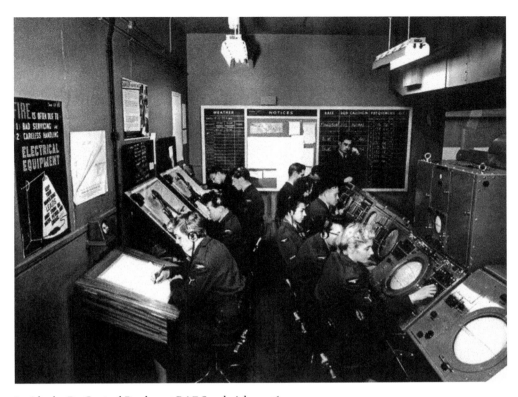

Inside the R3 Control Bunker at RAF Sandwich *c.* 1960.

pass information up to Sector Controls were now too slow to be effective. To counter this a new Type 80 radar was quickly introduced which had a range of up to 320 miles compared to the 90-mile range of the Type 7. Another significant benefit of the Type 80 radar was its capability to work with an automatic plotting system. It also came with an enormous financial benefit as it would enable the abandonment of most of the wartime Chain Home stations with an annual capital saving of £1.6m and a reduction in annual running costs of £1.5m.

Sandwich initially survived the cuts, and it was proposed that it should be equipped with a variety of new and upgraded radars, including a Type 80. However, in April 1958 491 Signals Unit was disbanded and RAF Sandwich closed as an operational radar station.

The site remained in MoD ownership until 1965 when part of it was returned to its original civilian owners while the rest was transferred to the Civil Aviation Authority who installed their own radars and used the R3 bunker as an air traffic control room. In the 1980s the site was repurchased by the Royal Air Force and renamed RAF Ash operating as a Reserve Control and Reporting Centre, an Operational Conversion Unit and a Ground Environment Operational Evaluation Unit. Following the end of the Cold War the site was closed and was sold in 1998 to a private company for use as a secure data centre.

Another Kent Rotor site was established at St Margaret's-at-Cliffe, near Dover. Known as RAF St Margaret's Bay, it was another former wartime Chain Early Warning radar station

The exterior of R3 bunker at the former RAF Sandwich/Ash.

that, in 1944, was equipped with a Type 13 and a Type 26 radars. The station was located at Bockhill, adjacent to the Dover Patrol War Memorial and came under the auspices of No. 90 Group RAF until 1949 when it was transferred to No. 11 Group, Fighter Command.

In the early 1950s RAF St Margaret's Bay was chosen to be included in Stage 2 of the Rotor project. An R1 Type single-storey underground operations bunker and other associated buildings were constructed to provide Centrimetric Early Warning capabilities (CEW) and the facility renamed as No. 1 Signals Unit.

The guardroom and entrance to the R1 bunker was constructed to look like a domestic bungalow in an attempt to disguise its true purpose. In order to provide communication between the controllers in the R1 CEW bunker at St Margaret's and the intercepting aircraft, two VHF/UHF multi-channel radio transmitter and receiver blocks were built at remote sites off Station Road in St Margaret's-at-Cliffe village. In 1952 No. 1 Signals Unit also took over responsibility for its close neighbour, the wartime Chain Home radar station RAF Swingate, whose re-engineered equipment was operational in the long-range early warning role as part of the wider Rotor plan.

Because of delays with the introduction of the new Type 80 radars, the Air Ministry turned to America for a 'stop-gap' solution, which they found in a 25-cm radar set known as the AN/FPS-3. Twelve of these sets were purchased as interim equipment for CEW sites and, in 1952, St Margaret's was chosen to serve as the prototype station for the American set.

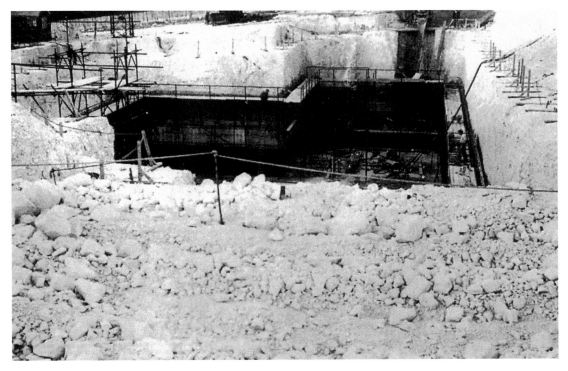

The R1 bunker under construction at RAF St Margaret's Bay.

St Margaret's eventually received its new Type 80 radar in September 1955 but was only operational until 1958 when No. 1 Signals Unit was disbanded and the St Margaret's Bay site was placed into 'care and maintenance'.

Responsibility for the inactive station was transferred to RAF Sandwich until 1960 when it was then transferred to RAF Manston. In 1970 the St Margaret's Bay site was placed with Defence Lands for final disposal. In the mid-1970s the County Planning Officer noted that the site had become a 'grim eyesore' and recommended that the Rural District Council should purchase it and level the site to become an important amenity within the Area of Outstanding Natural Beauty. The 11.5-acre site was eventually purchased in September 1971 by Kent County Council (excluding the bungalow which was sold to a private individual) for the sum of £2,250. Except for the entrance bungalow, all the surface buildings on the Bockhill site were demolished and the land returned to nature. The underground R1 bunker is still there but is sealed up and the entrance bungalow is now a private residence. The remote transmitter and receiver buildings off Station Road still exist and have been repurposed for different uses.

Just prior to the disbandment of No. 1 Signals Unit at St Margaret's, the station at Swingate regained its autonomy as a separate command and named as No. 345 Signals Unit. Between 1958 and 1970, Swingate operated a Gee-H navigation system largely for the English Electric Canberra equipped bomber stations and later for the V-force nuclear bombers.

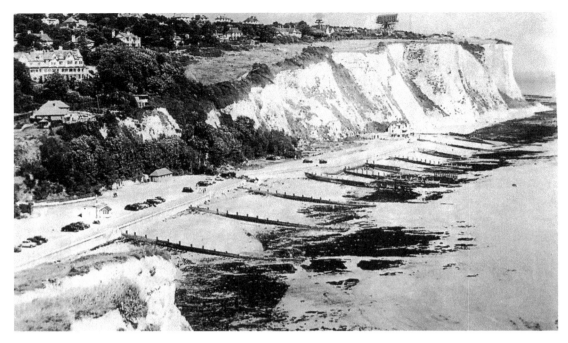

A 1950s postcard showing the Type 80 radar at RAF St Margaret's Bay.

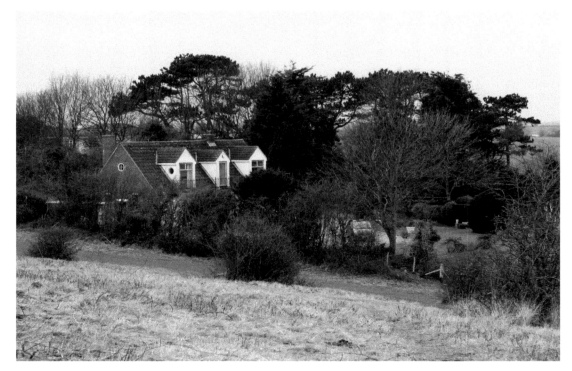

The guardhouse bungalow at the former RAF St Margaret's Bay in 2013.

In 1960, the site became part of NATO's 'Ace-High' international communication network, principally a means of linking NATO command centres in a crisis. Two large billboard reflectors for the tropospheric scatter communications network (part of the Ace-High system) were installed at Swingate, located on the transmitter site. The system was operational until the mid-1980s, by which time technological advances had made it redundant.

The Swingate site is still very active. The Ministry of Defence operates RRS (Remote Radio Site) Swingate, a defence ground-to-air communications facility. Two of the radar transmitter towers (one of which is an original Second World War tower) are still in use for various broadcasting and telecom companies including the BBC and O2.

The introduction of the NATO 'Ace-High' network saw the repurposing of another Second World War site in Kent. Friningham Wireless Station in Cold Blow Lane, just off Detling Hill, near Maidstone, was the wartime remote W/T (wireless telegraphy) site for the nearby RAF Detling air station. The airfield soon fell out of use after the war and most of the site was demolished and the land returned to agriculture.

The wireless station survived and was chosen in the mid-1950s as a location for four large parabolic dish antennae for use as part of the Ace High network. Once installed the station became known as RAF Cold Blow. The four parabolic dish antenna, each 60 feet in diameter, were supported on seven lattice steel girder legs. The transmitters, receivers and power supplies were located in a single-storey brick building between the pairs of dishes.

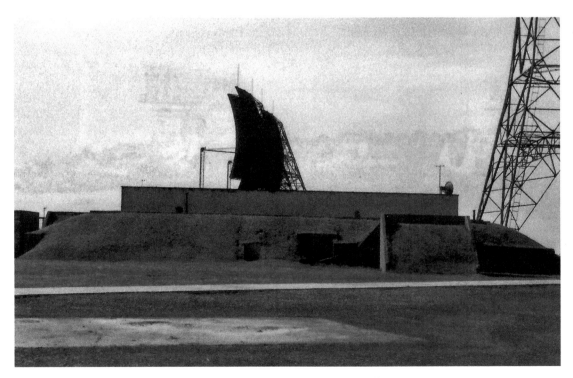

The 'Ace High' billboard reflectors mounted on the transmitter block at RAF Swingate.

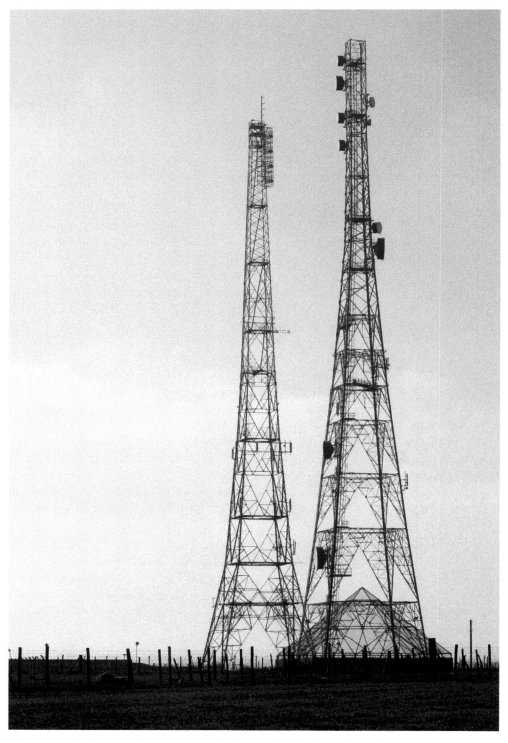

The two remaining transmitter towers at the former RAF Swingate in 2016.

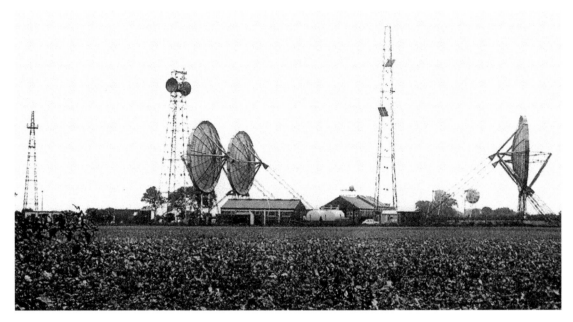

The parabolic dish antenna at RAF Cold Blow.

At completion in 1960 the network compromised forty-nine tropospheric scatter links and forty line-of-sight microwave links, extending from northern Norway and through central Europe to eastern Turkey. The system made available to the Supreme Allied Commander Europe (SACEUR) more than 250 telephone and 180 telegraph circuits. The system design of the network was tailored to meet the specialised requirements of Allied Command Europe, which needed reliable, secure and instantaneous communications to link its commanders in the European-wide command area. The network consisted of eighty-two stations divided almost equally between tropospheric forward scatter (over-the-horizon) and line-of-sight microwave radio stations. There were five stations in the United Kingdom.

Although it was a 'top secret' site, the four huge dishes at Friningham became a well-known local landmark, visible for miles. They were dismantled in the mid-1990s after the network fell out of use. The site remained in MoD ownership with one of the radio masts continuing in use by the US Air Force for some years. The site was eventually sold and, around 2016, it was redeveloped into housing, appropriately taking the name 'The Ace High Development'.

Since 1942 the United States had maintained various air bases in the UK and continued to do so, although to a much-reduced extent, after the end of the war. With the onset of the Cold War the American presence began to expand again. The US Strategic Air Command (SAC) were granted the use of the RAF station at Manston in Thanet as a rotational base for their fighter and fighter-bomber units and, on 11 July 1950, the 7512th Air Base Squadron was established at Manston tasked with providing support and administration services for the intended resident wings and squadrons. The first of those units, the 20th

Fighter Wing, arrived later in July with its F-84 Thunderjet fighters deployed to protect US nuclear-capable bombers from aerial attack while they were parked on their vulnerable airfields in East Anglia.

During 1951, the 31st and 12th Fighter-Escort Wings were deployed to Manston; the former stayed until June whilst the latter left at the end of November to transfer to Japan for combat duties in the Korean War theatre. In December, a National Air Guard unit, the 123rd Fighter-Bomber Wing, arrived at Manston and stayed until July 1952 when it returned to the US leaving behind some of its personnel and equipment to become part of the 406th Fighter-Bomber Wing which had arrived on 10 July. The three squadrons of the 406th initially operated F-84E Thunderjets; however, these were superseded in August 1953 by the nuclear-capable F-86 Sabre fighter-bomber. The F-86 could be deployed in the tactical nuclear strike role armed with one of the new small 'nukes' (second-generation tactical nuclear bombs) for use against massed armoured ground formations. To accommodate the Sabre's nuclear weapons several concrete bunkers were constructed by the USAF at Manston. The FB Wing remained at Manston until May 1958 when it was deactivated, and its squadrons redeployed to US bases in France and West Germany. The US presence at Manston finally ended in June 1958 when the base was returned to RAF control.

By the late 1950s Britain had its own independent nuclear deterrent based on the RAF's 'V-force' of Valiant, Victor and Vulcan bomber aircraft. The V-bomber

The Crash Fire Station at the former RAF Manston built by the Americans in the 1950s.

squadrons' main bases were located at ten airfields in central and eastern England. However, to forestall the effects of any enemy attack on these main bases, a further twenty-six airfields throughout the United Kingdom were designated as dispersal bases. In times of heightened international tension, the V-bomber force, already loaded with their nuclear weapons, could be flown to the dispersal bases where they could be kept at a few minutes' readiness to take-off. The bases were situated around the United Kingdom in such a way that a nuclear strike by an attacking state could not be guaranteed to knock out all of Britain's ability to retaliate. RAF Manston was selected to be one such dispersal base, capable of handling up to four of the nuclear-armed bombers. However, apart from during exercises, Manston was never called upon to fulfil this terrifying role.

In 1959 Manston became a joint RAF base and civilian airport. The first civil airline operations were those of Silver City Airways who were joined in later years by Invicta Airways, Air Ferry, Air Holdings and Interland Air Services.

In 1960, thanks to its long runway, Manston was designated as one of the UK's MEDAs (Military Emergency Diversion Airfields) for emergency military and civilian landings. For several years, the base operated as a Master Diversion Airfield, open 24 hours every day. Manston, uniquely in the UK, also had a 'foam carpet' crash-landing system, where two tractors would pull tankers laying a metre-thick layer of foam over a strip of runway, for aircraft with landing gear problems.

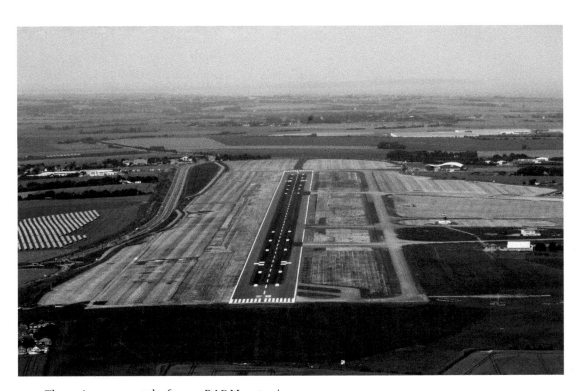

The main runway at the former RAF Manston in 2015.

Meanwhile RAF operations at the airfield continued from 1961 with 22 Squadron helicopter search and rescue (SAR) flight covering the English Channel from Manston with their Westland Whirlwind helicopters. The SAR role continued into the 1970s with 72 Squadron operating two Westland Wessex HC2 machines and then, in 1988, 202 Squadron moved to Manston equipped with their Sea King HAR.3 helicopters. The Sea Kings remained at Manston until July 1994, when SAR activity at the base was halted, and SAR cover for the channel relocated to RAF Wattisham.

The RAF base at Manston closed in 1999 but civil aviation operations continued with the airfield re-styled as Kent International Airport. The Ministry of Defence retained the Domestic Site for use as the Defence Fire Training and Development Centre which is also used as base for the 3rd Battalion Princess of Wales Royal Regiment, an Army Reserve light infantry unit.

Kent International Airport closed in May 2014 and, at the time of writing, its future remains uncertain.

Local Government and Civil Defence

In 1948, as the Cold War was developing, Parliament passed the Civil Defence Act which set out legislation for civil defence procedures in the UK. The Act imposed a duty on local authorities to make plans for the continuation of essential services in wartime. The first set of regulations issued under the Act, in July 1949, empowered the local authorities to appoint Civil Defence Committees and recruit members for the new Civil Defence Corps.

The new Civil Defence structure remained almost identical to that which had been in place during the Second World War with the country divided up into twelve Regions each under the command of a Regional Commissioner. As during the war, Kent was part of Region 12 (South-East Region). The role of the Commissioner was one of directing the rescue and recovery functions of the Civil Defence organisation and ensuring the continuing delivery of essential services. In extreme circumstances he was also mandated to assume the authority of central Government in his Region.

In early 1949 the Civil Defence Joint Planning Staff had already recommended the provision of protected control rooms with signal communications at local authority, zone, region and central government level. This led to the setting up of the Working Party on Civil Defence War Rooms which initially concentrated on planning war rooms for the eleven civil defence regions outside of London. The new War Rooms were to be built in the same regional centres as their Second World War predecessors but outside the towns' main residential and commercial areas. For Region 12 the site chosen for the new War Room was in Forest Road, Tunbridge Wells. The War Room was a two-storey structure, with a reinforced-concrete roof and walls 5 feet thick.

By the time construction had completed, in 1953, the Soviet Union was a nuclear power and radioactive fallout had become recognised as a greater danger than the bomb's initial explosive power. As a result, the ventilation and air filtration of the Regional War Rooms was greatly improved requiring a large single-storey extension to one side of the War Room to house the new plant.

The War Room was built to accommodate the Regional Commissioner with his staff and advisors together with representatives of the Civil Defence Corps, the emergency services

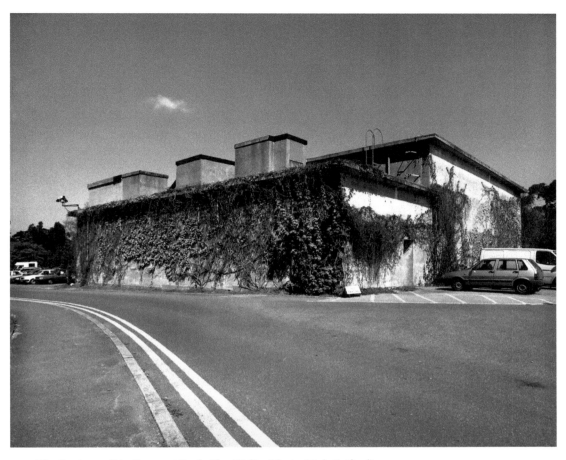

The Region 12 War Room at Tunbridge Wells. (Photo: Nick Catford)

and some military liaison officers: a total of around fifty people. There would also be a few representatives of the government departments involved in civil defence. The operational heart of the building was the two-storey Operations & Map Room, the internal walls of which were built from substantial reinforced concrete forming a hardened 'inner sanctum'. It was staffed by volunteers drawn from the local offices of government departments. A huge regional map would fill one wall which was overlooked by control cabins with curved, Perspex windows. The map was made of metal, allowing the use of magnetic symbols which could be moved around as required by the Operations Room staff.

The main operational duties to be carried out in a Regional War Room were:

Receive and collect reports –

(1) on air raid damage and casualties occurring within the region.
(2) of other important events which are important because of their effect on the prosecution of the war.

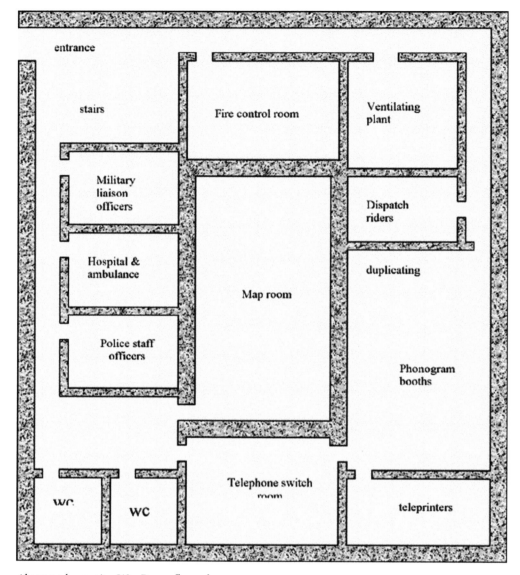

Above and opposite: War Room floor plans.

Order the movement of reserves to areas which have suffered damage or casualties beyond the scope of their local resources.

When the situation demands such measures –
(1) call for assistance from other fighting services, or
(2) ask the Civil Defence Central War Room to send reinforcements from other regions.

Supply the Civil Defence Central War Room with regular situation reports.

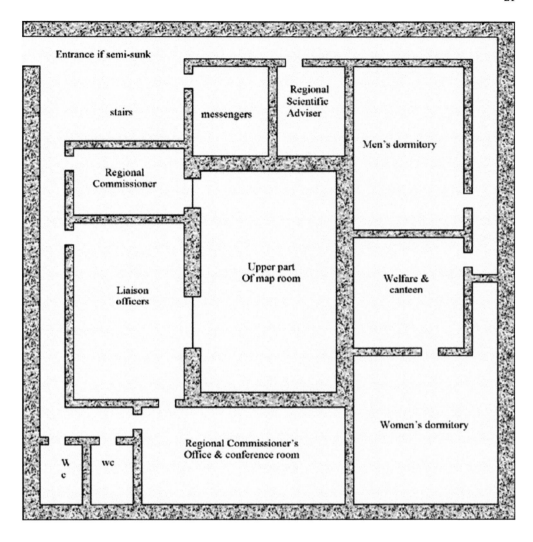

Ensure, by means of a general oversight of the conduct of operations within the region, that available resources are deployed to the best advantage.

Liaise with and make essential information available to the fighting services, the regional headquarters of government departments and all authorities concerned with any aspect of civil defence.

Circulate to those concerned information regarding the enemy's tactics, the types of weapons in use by the enemy and their probable influence on operations.

By 1956, the functional value of the Regional War Rooms was being seriously questioned. The possession of the hydrogen bomb by the Soviet Union dramatically changed the perception of any future war and required a complete reappraisal of the UK's civil defence plans. There would no longer be a prolonged period of conventional air bombardment before an escalation into limited atomic warfare and gradual attrition; instead, the

country faced the prospect of short nuclear war with the instant destruction of its cities and infrastructure followed by months of ruin and social collapse. The spectre of the radioactive fallout from several nuclear bombs would have continued consequences for the health of survivors for years to come.

The Civil Defence requirement was now for a larger regional control system strong and stable enough to guide the recovery process through the months and years ahead. The existing Regional War Rooms were simply not up to this long-term task and so the Home Office began the task of identifying sites for new Regional Seats of Government (RSGs). By late 1958 the wartime tunnel complex under Dover Castle had been designated as the RSG for Region 12 and the Tunbridge Wells War Room closed.

After its closure, the War Room bunker was retained by the Home Office on a 'care and maintenance' basis. It was reactivated in 1963 as a Sub-Regional Control, for South-East London (SRC51), taking over from another Kent site, Fort Bridgewoods, near Rochester. SRC51 remained active at Tunbridge Wells until a further reorganisation of the Sub-Regional Control system in 1972. The bunker then became the home of the first Police National Computer and when that was moved to Crowborough it was relegated to duty as an archive repository. The bunker was eventually demolished in 1997 to make way for a new Land Registry complex.

In 1963 and 1964 new sets of regulations came into force which required all local authorities, from district council level upwards, to maintain a protected emergency control headquarters which could be activated at two hours' notice. The regulations also defined the authorities' wartime responsibilities, the principal of which would be the restoration of services. At a county level this meant the maintenance of law and order; the provision of foodstuffs, fuel and power; the maintenance of a basic level of public health; and the clearance of essential transport routes.

During the early years of the Cold War, Kent County Council had maintained an Emergency County Control in the basement of County Hall in Maidstone town centre which had served a similar purpose during the Second World War. In 1964, the Control was moved to a purpose-built, self-contained bunker at the KCC's Springfield offices on the outskirts of Maidstone. The bunker was built as a single-storey, reinforced-concrete structure beneath a light steel-framed meeting room building, the collapse of which would cause little damage to the bunker below.

As with the War Rooms, the 'beating heart' of the County Control bunker was the Operations Room where activity would be co-ordinated in response to intelligence reports. These reports would be received by various offices in the bunker including the Information Room, the Liaison Room and the communications rooms. The County Controller and his staff would assess the information in the reports and would issue instructions accordingly to the emergency services and other officials. The bunker was designed to accommodate up to eighty personnel including County Council employees, representatives of the emergency services, military and police liaison officers and scientific advisors. In an emergency, communications with the outside world could be supplemented by using amateur radio enthusiasts, who were members of the Radio Amateur Emergency Network, 'Raynet'. Although there was no official central government link with the network, the use of Raynet stations was a feature of many county council War Plans.

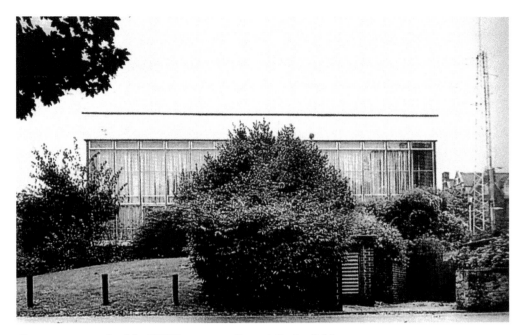

The emergency exit of the KCC Emergency Control, Springfield.

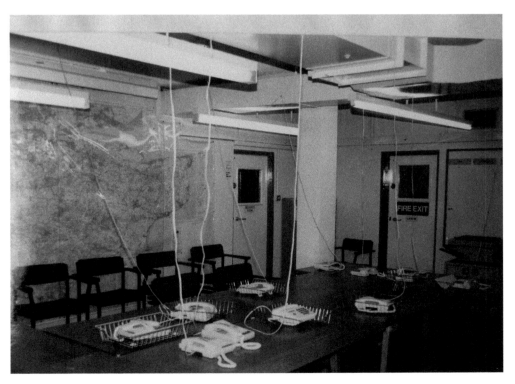

The Operations Room at KCC Emergency Control, Springfield. (Photo: Victor Smith)

The bunker was designed to be self-supporting for several weeks and was equipped with a stand-by generator, air-filtration plant, kitchen, toilets and storeroom/dormitory. It was refurbished and extended in 1984 when modern concrete and steel blast doors were fitted, and the air-filtration plant updated. However, a later structural survey found that the ceiling reinforcement was inadequate and, as a temporary measure, sandbags were stacked on the floor above. Plans were drawn up for strengthening work, but the bunker was closed down in 1999 before the work could commence.

Many District and Borough Councils also had their own emergency control bunkers. Dartford had a 'reinforced refuge' within the Civic Centre; Dover had a converted basement below the municipal offices, although this was only completed in 1989; Sevenoaks had a protected basement in its modern council headquarters; and Tonbridge and Malling had a specially constructed bunker built between the two wings of its offices in the former RAF West Malling Officers' Mess. Medway had two bunkers: one was a purpose-built underground bunker in the car park of the council offices in Gillingham and the other was a surface bunker in the car park of the Rochester Civic Centre. Many of the other councils in Kent just made do with rooms in their unprotected surface offices and others just never got around to providing any emergency control before the Cold War came to an end.

Public Utilities

The major public utilities all made their own preparations for war. The National Grid established eight regional control centres in extensive blast-proof accommodation. The South-Eastern Region of the Central Electricity Generating Board (CEGB), of which Kent was a part, had its peacetime regional control centre at Bankside power station on the south bank of the River Thames, opposite the City of London, but in the event of war, this would move to an emergency control centre at East Grinstead in Surrey. The South Eastern Electricity Board (See board) would have their representatives along with those from the CEGB operating in the Regional Seat of Government at Dover Castle.

After any nuclear attack, the CEGB expected widespread damage to the National Grid and electricity distribution systems. The nuclear power station at Dungeness would be an almost certain target for an attack, as would many conventional power stations including those at Kingsnorth and Grain on the Hoo Peninsula.

Even if they were not direct targets, the power stations could be severely affected by the radiation fallout from other nuclear explosions. Fallout particles, drawn into cooling systems, could build up severe radiation hazards if the power stations continued to operate. Even if the conventional stations survived, they would not be able to operate for long as their fuel supplies would soon dry up as stocks of oil and coal were depleted. It would be many months before even a rudimentary supply grid could be re-established; even then priority for electricity supply would be given to essential services, government, communications, military and industrial users. Surviving domestic consumers could remain without power for a year or more.

Similar problems would affect water services. The responsibility for providing water supply after a nuclear attack would rest with the ten Regional Water Boards in England and Wales and some local authorities. In the 1980s the government specified a minimum

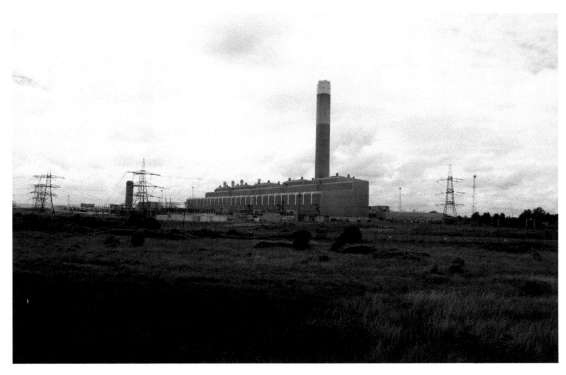

Grain Power Station in 2012.

emergency supply of 2 litres per day to every survivor of a nuclear attack. Following an attack, each water authority would need to improvise whatever system of supply seemed most feasible. Although it was not thought that water mains were likely to sustain extensive damage themselves, major disruption to supplies would be caused by any long-term loss of electrical power which would affect pumping stations and treatment works. Stockpiles of generators, pumps, piping, sterilization equipment and tanks were held at special emergency depots. The water boards would also be responsible for sewage disposal which would become very problematical in the event of any failure of water supply, which would prevent the normal use of WCs and other sanitary facilities.

It became obvious that the water authorities needed to continue to operate effectively after any nuclear attack and that some emergency control facilities would be needed. To this end the Home Office provided 100 percent grants to the water boards to construct sufficient emergency control bunkers to sustain operations in their regions. Southern Water was one of the Regional Boards with the responsibility for parts of Kent and, during the late 1980s they built an emergency control bunker near Gillingham to serve the Medway area. Located at Hartlip, just south of the Medway services on the M2, the bunker was built within a disused covered reservoir and now lies within a large fenced compound.

It is mounded over with earth and grass with two short ventilation towers on top and a recessed entrance on the north side. There is an emergency exit shaft at the rear of the

The former Southern Water Emergency Control bunker at Hartlip in 2014.

Airlock inside the former Southern Water Emergency Control bunker.

mound accessed through a manhole cover. The main entrance is through a wooden door and down a flight of steps. At the bottom of the steps is a steel and concrete blast door which leads into the decontamination room. From here two further blast doors lead, one to an airlock and the other to a standby generator room. From the air lock, another blast door opens into the spine corridor off which are the dormitory, storeroom, toilets and a kitchen. At the end of the corridor is the control room in which stands a large Faraday Cage which would have protected sensitive electrical equipment from damage from the extreme electro-magnetic pulses caused by nuclear explosions.

The construction of the bunker was completed in 1990 just as the Cold War was coming to an end, so it was never fully fitted-out or ever used. It now stands empty and derelict, its future uncertain.

Part Two: Chatham Dockyard – Nuclear Submarine Refitting and Refuelling Complex

In 1547, the last year of Henry VIII's reign, a storehouse was rented alongside the banks of the River Medway at Chatham to store the ropes, masts and other equipment of the royal warships that had, for some years, been using the river as a safe anchorage during the winter months. The acquisition of this building marked the genesis of one of the nation's greatest and most important naval dockyards.

In subsequent years the facilities were expanded to cover an area that was later to be known as the Gun Wharf and by the 1570s it had been fully established as a Royal Dockyard with storehouses, a mast pond, saw pits and a forge. In 1581, a dry dock was completed so ships could be 'graved' to enable their hulls to be repaired and maintained.

By 1613 the dockyard had outgrown its original location so an area of around 80 acres was acquired to the north of the old yard. Dry docks, wharves, cranes, a sail loft, ropehouse and officers' residences were built here between 1619 and 1626, by which time the new

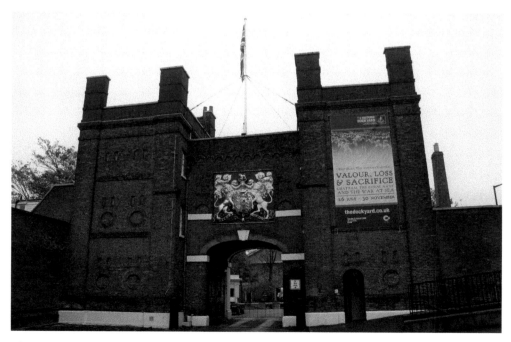

The Main Gate to Chatham Dockyard constructed in 1722. Photographed in 2014.

yard was fully operational and by the end of the century it extended to an area covering most of what is now the site of the Historic Dockyard.

Between 1780 and 1830 many of the yard's industrial processes were mechanised. A new double ropehouse was constructed at the southern end of the yard and the famous engineer Marc Brunel designed and built a steam-powered sawmill which, together with its underground waterway and overhead rail system, automated the handling and sawing of the 12,000 tonnes of timber that the yard consumed each year.

By the mid-nineteenth century new technologies such as iron and steam had been introduced into shipbuilding at the yard. New slips, docks, workshops and smitheries had been built to handle these new processes but with the ever-increasing size of the Royal Navy and its warships the demands on the yard were rapidly outgrowing its facilities.

In 1862 work commenced on a massive expansion and modernisation of the yard which would add 380 acres to its existing 97 acres. Most of the new work was concentrated on St Mary's Island to the north of the yard. The marshland there was drained ready for the construction of three huge new basins. Eventually five new docks and a new building slip were incorporated into the expansion together with numerous new workshops, pumping stations, storehouses and a railway system. The major works continued into the early years of the twentieth century with the new No. 9 Dock being completed in 1903.

The dockyard continued to serve the Royal Navy through both World Wars. Although the yard had built its last battleship, HMS *Africa*, in 1905 it was still engaged in

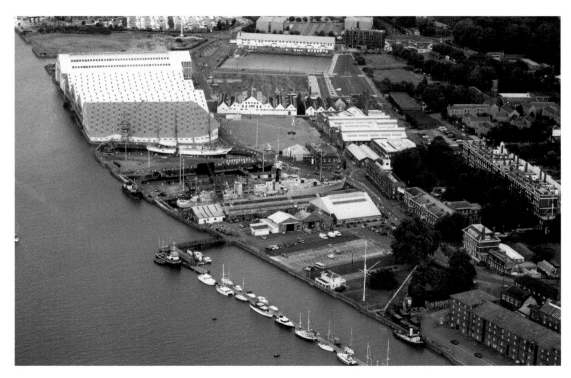

Chatham Historic Dockyard from the air in 2016.

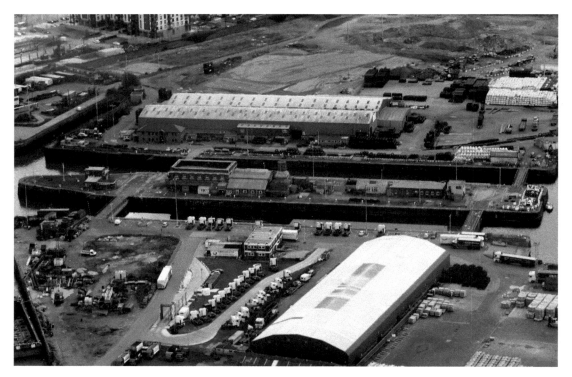

The 'Bull Nose' lock entrance to Chatham Dockyard, built in 1877 as part of the Dockyard Extension Works.

construction of the smaller classes of warships and had also become established as a specialist builder of submarines.

In the early 1950s, with the reduction in size of the Royal Navy following the end of the Second World War, the dockyard faced an uncertain future. The workforce had been rundown, and the yard had been obligated to supplement its work with civilian contracts. However, the yard continued to be active in the refitting and maintenance of the Royal Navy's submarines and surface vessels. The latter were mostly from the smaller classes of vessel such as destroyers and patrol vessels, but occasionally the yard was called upon to work on larger ships. One of these was the former wartime escort carrier HMS *Campania*. In 1952 she entered No. 9 Dock to be fitted out as the flagship for the first British nuclear bomb tests at Montebello Islands, off the coast of western Australia. Another vessel based at Chatham at the time was the frigate HMS *Plym*, which was also to be involved with the nuclear bomb tests. It was her unfortunate task to be used as the detonation platform for the bomb. On 3 October 1952, a 25-kiloton device was detonated on the vessel, obliterating her completely.

The Defence White Paper of 1957 instigated a further decline of the Royal Navy's activities on the Medway and doubts were again being expressed about the future of the dockyard, but these were allayed when orders were received for the construction of the new Oberon class of submarines. A total of six of the class were built at Chatham,

including HMS *Ocelot*, which can now be seen on permanent display in No. 3 Dock in the Historic Dockyard.

A further three vessels of the class were built at Chatham for the Royal Canadian Navy. The last of these, HMCS *Okanagan*, was launched on 17 September 1966, an occasion that became a significant landmark in Chatham's history as the launching of the last ever warship built at the dockyard.

The advent of the nuclear-powered submarine and the adoption of it by the Royal Navy at first seemed to predict the final death knell for Chatham Dockyard. Britain's first, HMS *Dreadnought*, launched in 1963, had been built at a private yard, Vickers Armstrong in Barrow-in-Furness. Chatham did not possess the facilities to either build or refit these new types of submarines and there were too few contracts for the refitting of surface vessels to keep the yard viable long term. However, one positive spin-off of the nuclear programme for the dockyard was that it was chosen to convert the large depot ship HMS *Forth* into a support vessel for the new nuclear submarine fleet.

In the meantime, the Admiralty Board was assessing the need for further refitting capacity for nuclear submarines. The Labour government, elected in October 1964, had cancelled the fifth ballistic missile submarine in the Polaris programme, insisting that four boats would be adequate to act as Britain's nuclear deterrent. This brought the hunter-killer submarine programme forward. *Dreadnought* had been in commission since 1963, *Valiant* was due to enter service at the end of 1965 and *Warspite* would follow

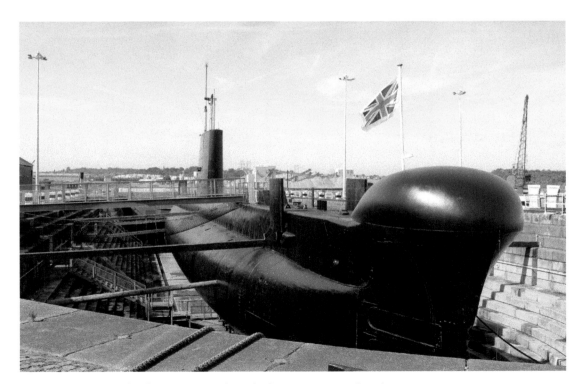

HMS *Ocelot* on display in No. 3 Dock at Chatham Historic Dockyard.

a year later and, with the Polaris programme running in parallel, the need for additional submarine refitting facilities was becoming evident. To ensure that Rosyth had the capacity for the refits of the Polaris fleet, it was decided to develop another refitting yard for the hunter-killers.

In May 1964, a meeting was convened of the Nuclear Warships Safety Committee to examine the assessments of the various possible refitting yards which included Chatham. Concerns were expressed regarding the shallow approaches to the dockyard from the River Medway. The committee concluded such hazards to be 'insignificant' and that the danger of a nuclear submarine grounding in the shallow approaches to the yard was 'improbable'. It was considered more likely that in the event of an accident the vessel would submerge, in which case its nuclear reactor core was unlikely to endure a meltdown and any contamination could be contained.

The choice of Chatham as the refitting and refuelling port for the nuclear hunter-killer submarine fleet was announced in the House of Commons on 11 March 1965. Despite local concerns about radiation safety, building approval was soon granted and work commenced on the construction of the complex which was to be sited between No. 6 and No. 7 Docks in No. 1 Basin and, when completed, would allow for two submarines to be worked on simultaneously.

In December 1966, whilst the new complex was still under construction, HMS *Valiant* became the first nuclear-powered submarine to visit Chatham Dockyard when she arrived in No. 1 Basin to test docking procedures and to undergo a survey prior to her return in June the following year for essential maintenance.

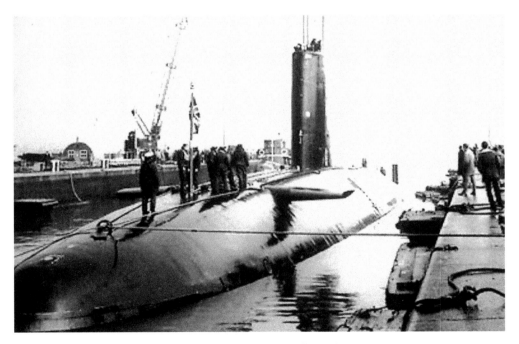

HMS *Valiant* entering Chatham Dockyard through the 'Bull Nose' in 1966.

HMS *Warspite* was the second nuclear submarine to be worked on at Chatham, arriving there in March 1968 for maintenance and repairs and leaving in June. Both *Valiant* and *Warspite* made some further brief visits to Chatham for essential maintenance over the following eighteen months.

The Nuclear Refitting and Refuelling Complex was opened by the Controller of the Navy, Vice-Admiral Horace Law, on 29 June 1968. The complex included a ten-storey office block, a health physics building, workshops and a refuelling crane. A nuclear store was also built to house over 10,000 items ranging from small pipe joints to reactor covers, needed during the refit process.

The site was dominated by the huge 1,700-ton hammerhead refuelling crane, standing over 160 feet high, which was used for lifting the nuclear reactors and other heavy equipment in and out of the submarines. The crane's operator probably enjoyed the best view of the dockyard but had a long climb to get to it and to save him climbing up and down during his working day some basic living quarters were incorporated within the crane's structure with toilet, washing and cooking facilities.

Work on submarine nuclear reactors was very hazardous. Refuelling involved replacing the uranium reactor core. It was not possible to remove the reactor to a workshop on shore for refuelling. Instead, a special portable workshop, known as the Reactor Access House, was attached to the submarine's hull for the operation.

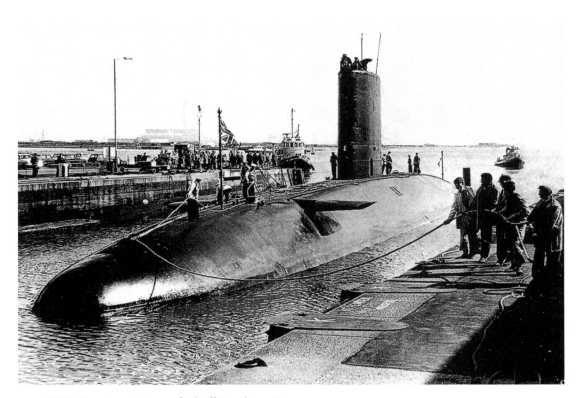

HMS *Warspite* arriving at the 'Bull Nose' in 1968.

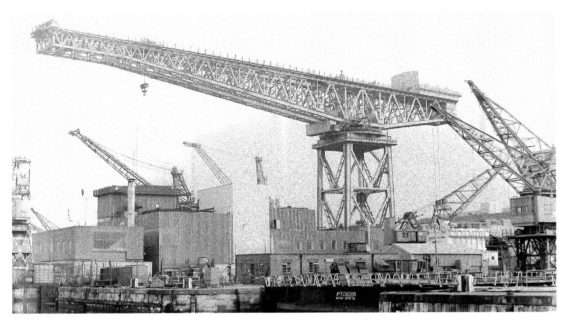

The Nuclear Refitting and Refuelling Complex hammerhead crane.

The first submarine to use the complex was HMS *Valiant*, which entered No. 6 Dock in May 1970 and was returned to the Fleet two years later. During that time, she had been refuelled and completely refitted. *Valiant* recommissioned at Chatham in May 1972 and returned for a second refit in 1977.

HMS *Warspite*'s first refit at Chatham was completed in November 1973. At the time, it was the most extensive refit ever completed on a Royal Navy nuclear submarine. The proving and testing work on the reactor and propulsion plant were undertaken in record time. *Warspite* undertook a second refit at Chatham between 1979–82.

In 1975, Chatham Dockyard became the first dockyard in Britain to undertake the refitting work of two nuclear submarines – *Churchill* and *Dreadnought* – at the same time. This was known as 'dual streaming'. In October 1975, the dockyard even entered into 'triple streaming': *Churchill* awaited recommissioning at the end of the month, *Dreadnought* remained in refit, and *Conqueror* entered refit for the first time at Chatham.

Chatham's workforce of fitters and turners had to undergo specialist training regarding their own cleanliness and the cleanliness of their work before they able to work in the reactor compartment of a nuclear submarine. Welders also had to be specially trained to undertake work on nuclear boats' pressure hulls and reactor heads. They, along with other specialist workers, had to periodically requalify to engage in such work.

Throughout the 1970s the dockyard continued with its nuclear submarine programme whilst continuing to be engaged with the refitting and repairing of some smaller surface ships and was also still home to elements of the Reserve Fleet including the Frigate Standby Squadron. For a while it seemed that the yard had a bright future, but this optimism was dashed when, on 25 June 1981, the Secretary of State for Defence,

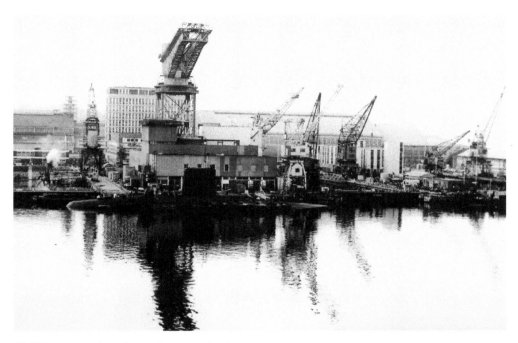

HMS *Dreadnaught* at the nuclear complex in 1975.

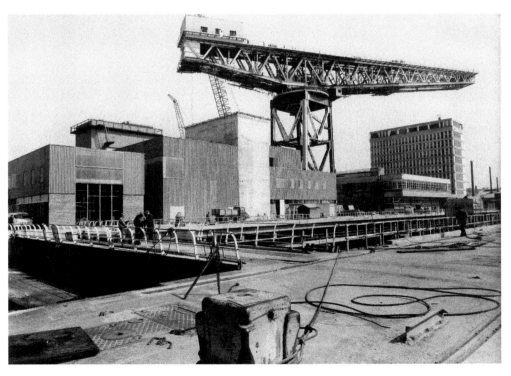

Above and overleaf: The nuclear complex *c.* 1978 and similar view in 2013.

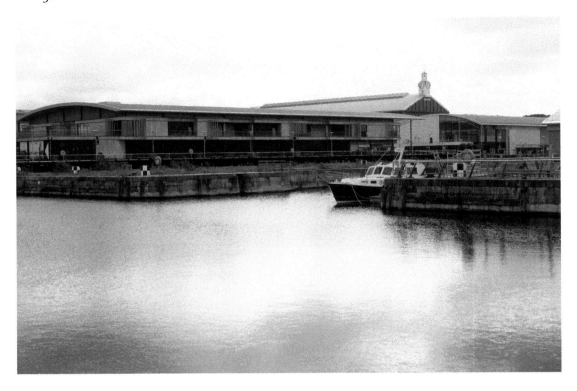

John Nott, announced to the House of Commons that the Chatham Navy Base was to close by 31 March 1984.

Meanwhile HMS *Churchill* had arrived at Chatham for her second refit in November 1980. She was enclosed in over 80,000 feet (24,000 m) of scaffolding poles stretching for 15 miles (24 km). The scaffolding took two months to erect in the spring of 1981. It enabled a double skinned plastic canopy to be fitted, which allowed the temperature and humidity around the submarine to be carefully controlled, as a massive fit-out of acoustic tiles took place. *Churchill*'s second refit was the final submarine refit to be undertaken at Chatham Dockyard. For 70 percent of the refit period, the axe of closure was hanging over Chatham Dockyard's workforce. This refit was described by the workforce as 'Chatham's Test – our Last and Best'. T-shirts were even printed carrying this slogan. HMS *Churchill* sailed from Chatham for the final time on 23 May 1983.

The nuclear submarines *Valiant, Warspite, Churchill, Conqueror, Courageous* and *Dreadnought* were all refitted and refuelled at Chatham Dockyard between 1970 and 1983. The later Swiftsure class HMS *Sovereign* was also refitted at Chatham. Nine major refits were completed during this period, plus numerous 'mini' refits and 'DED' (Docking and Essential Defects) works. HMS *Dreadnought* also completed her final decommission at Chatham in 1983.

On 30 September 1983 Chatham Dockyard's closure was marked with an emotional Haul Down Ceremony in front of hundreds of dockyard workers and various dignitaries, as well as press and television from all over the world. By the end of February 1984

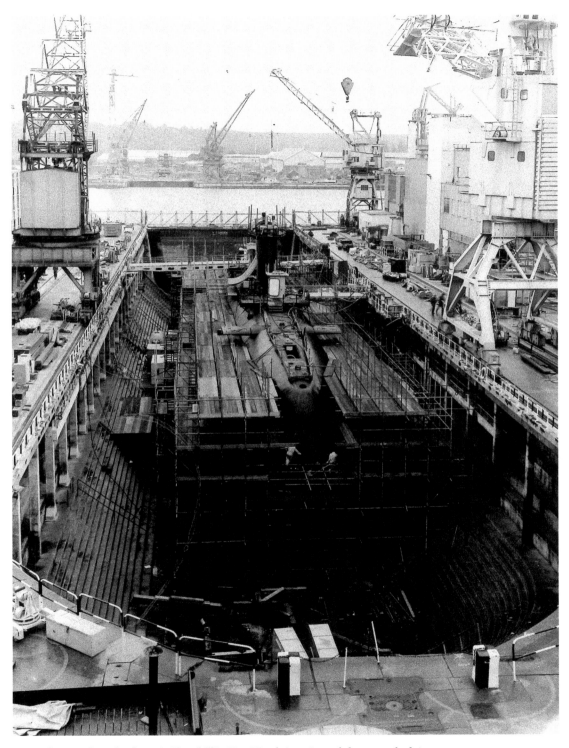

Above and overleaf: HMS *Churchill* in No. 6 Dock in 1980 and the same dock in 2010.

Chatham Royal Dockyard was completely vacated and the Ministry of Defence police locked its gates for the last time on 31 March 1984, thus ending Chatham's 450-year association with the Royal Navy.

Today, the Georgian dockyard is open to the public as Chatham Historic Dockyard with most of its original buildings intact. Little remains of the dockyard buildings of the Victorian extension on St Mary's Island and the nuclear complex there was completely demolished shortly after the dockyard's closure. The basins and docks remain with No. 3 Basin now used as Chatham Docks and No. 1 Basin as a marina.

Civil Defence Control Centre – Gravesend

The Civil Defence Service had played a vital role during the air raids and shelling of the Second World War. The Service included the ARP Wardens Service as well as firemen (initially the Auxiliary Fire Service (AFS) and latterly the National Fire Service (NFS), fire watchers (later the Fire Guard), rescue services, first-aid post and stretcher parties. Over 1.9 million people served within the CD and nearly 2,400 lost their lives to enemy action.

With the end of the war in Europe in sight, the Civil Defence Service was disbanded on 2 May 1945 and its infrastructure and organisation was soon being dismantled. Vehicles, premises and equipment were disposed of and personnel stood down. The Service had the honour of a final parade in front of Their Majesties the King and Queen in Hyde Park

on 10 June, but there was much resentment of the rapid pace with which the CD Services had been dispensed with and many feared its disbandment was premature.

The Home Office still encouraged local authorities to plan for future war contingencies and funded the maintenance of Civil Defence Associations to try and keep together veterans of the Service. However, having just suffered six years of conflict, the local authorities now had other priorities, not least for many of them the rebuilding of their war-ravaged communities.

As relations between the Soviet Union and the Western allies cooled in the aftermath of victory, so tensions increased culminating in the summer of 1948 with the Berlin Blockade. The worsening international situation prompted the British Labour government to introduce the Civil Defence Act which received Royal Assent on 16 December 1948. The Act placed a duty on local authorities to reintroduce civil defence measures. These measures included the establishment of a volunteer Civil Defence Corps, an organisation with many similarities to its wartime predecessor.

Although at the time the Soviet Union did not possess the atomic bomb, their air force could still pose a major threat to the UK with the use of conventional high-explosive bombs and poison gas. The Thames Estuary area contained many prime bombing targets including Sheerness and Chatham naval dockyards, Tilbury docks, Grain oil storage depot and several power stations. These targets made all north-east Kent very vulnerable to attack, in particular major towns such as Dartford and Gravesend.

In Gravesend recruitment into the new Civil Defence Corps was slow and it was eighteen months before numbers made work on further organisation worthwhile. The search was then on to find suitable operational premises. Some rooms at Milton Chantry, next to New Tavern Fort, were secured to use for training purposes and a secretariat was established in council premises at Woodville Terrace. However, neither of these were suitable to house a control centre. During the war, the Civil Defence Control Centre had been housed in the basement of the police station in Windmill Street and most of the physical infrastructure was still in place there; however, the police refused permission for it to be reactivated. Other premises that were considered included the wartime air-raid shelter tunnels on the A. T. Henley factory site at Northfleet, the magazine tunnels at New Tavern Fort and the entire ground floor of Milton Chantry. However, none of these options were pursued and, in 1951, the government issued its guidelines for the design and operation of Control Centres. These included requirements for Control Centres to be resistant to a direct hit from a high-explosive bomb and to be sited away from prime target areas. Following the issue of these guidelines, a site was chosen for a purpose-built, hardened Control Centre bunker for Gravesend, away from the town centre at Woodlands Park, just off Wrotham Road.

Construction commenced in April 1953 using conventional 'cut and cover' deep excavation techniques. The site had been the location of a Second World War air-raid shelter but all trace of this was destroyed during the excavations.

The structure was built directly onto a sand bed without any piles. A metal reinforcement structure was first inserted onto which the concrete was then poured. No waterproofing was applied to the concrete, which would become a problem in later years.

PLAN OF THE BUNKER

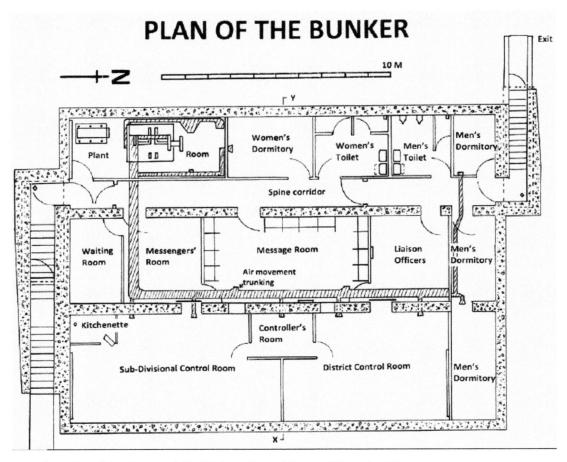

Floor plan of the Gravesend Civil Defence Control Centre. (Victor Smith)

By the summer of 1954 construction had been completed, at a final cost of £11,000, and the bunker fitted out. It was officially opened on 7 July by the Deputy Under-Secretary of State at the Home Office, Sir Arthur Hutchinson.

The bunker was operated as a dual-purpose Control Centre, serving the Borough of Gravesend Civil Defence District itself and, on a higher-level coordinating across the three Districts of the Gravesend Civil Defence Sub-Division (Gravesend, Northfleet and Swanscombe).

By the time the bunker opened the Soviet Union was a nuclear power with a strategic bombing force capable of reaching every part of the United Kingdom. The effects of a thermo-nuclear war between East and West was now at the forefront of civil defence planning. The Gravesend Control Centre would play a vital part in CD operations after a nuclear attack, receiving and collating damage reports and the subsequent issuing of orders for the deployment of CD resources. It would also be responsible for evaluating nuclear 'fallout' in conjunction with the Royal Observer Corps and for providing other emergency and defence services with access to information held within the Control

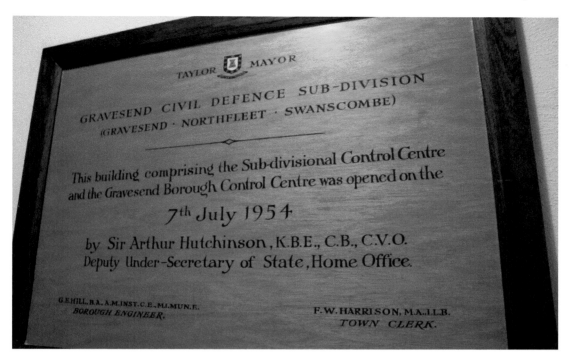

Plaque commemorating the official opening of the Control Centre.

Centre. The bunker would also provide information to the Civil Defence County Control at Maidstone with which a teleprinter link was maintained.

Access to the bunker was down a set of concrete steps from Wrotham Road. The entrance door opened into a spine corridor which gave access to all the rooms and led directly to the rear exit.

The interior of the bunker comprised of thirteen rooms on a single floor divided among four functional areas: emergency power, communications, control, and dormitories.

The Plant Room contained the ventilation machinery and an emergency generator. Sub-Division and District each had their own control rooms with the bunker Controller's office connecting them. They were entered through sliding doors from the Messengers' Room and the Liaison Officers' Room. There were separate dormitories and 'Elsan' chemical toilet facilities for male and female staff.

Local information would be received at the bunker by telephone, messenger or radio. Messengers would be shown into the Messengers' Room where they would hand over their message and receive a debriefing. The message would then be passed into the Message Room.

On receipt, the message details would be written down and passed into the relevant control room where the information could be plotted on wall maps. The original message would then be passed to the Operations Officer, with copies to the Controller and the Fire and Police Service Liaison Officers. The Operations Officer, after consultation with other heads of services, would pass instructions to the various CD and emergency services depots on how to respond.

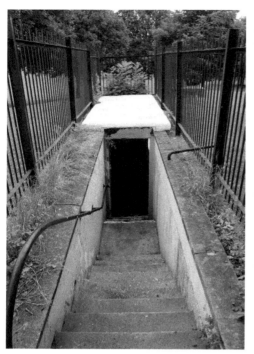

Above left: The entrance to the Control Centre.

Above right: The spine corridor through the Control Centre.

The Plant Room.

The Messengers' Room.

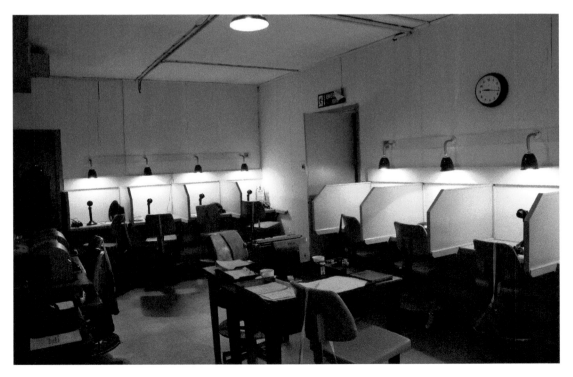

Telephonists' cubicles in the Message Room.

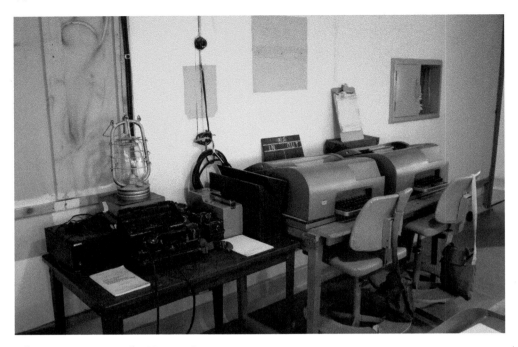

Teleprinter stations in the Message Room.

The establishment of the bunker would have been around thirty-five personnel, plus reliefs, made up of local civil defence volunteers, liaison officers and council staff, under the overall command of the Controller, Gravesend's Town Clerk.

By November 1957, thanks to various recruiting campaigns, the total strength of CD volunteers in the Gravesend Sub-Division had grown to 242 personnel. The volunteers engaged in regular training exercises and new premises for training were acquired in Gravesend, Swanscombe and Northfleet. Following a government decision to rationalise operational structures for civil defence in 1958, Kent's fourteen Sub-Divisions were reduced into seven 'Areas'. As a result of this reorganisation Dartford Municipal Borough and Dartford Rural District were added to the districts in Gravesend Sub-Division to form Area 'A' and Gravesend's Town Clerk appointed as Area Controller with his headquarters in the Woodlands Park bunker.

Further reorganisation of civil defence in the early 1960s saw Kent divided into twenty-nine Civil Defence Districts. Gravesend, Northfleet and Swanscombe separated from Dartford to form a single District. An additional layer of sub-control was also proposed to operate, below the Maidstone County Control, in the form of four Sub-Control Centres at Ashford, Tunbridge Wells, Canterbury and Gravesend. The Sub-Controls were also to 'shadow' controls in case the county control at Maidstone was put out of action. A result of this proposal was the planned conversion of the Woodlands Park bunker at Gravesend for use as a 'Sub-Control'. These plans envisaged the extension of the bunker with the construction of a fuel store, the provision of extra operational space, the relocation of sleeping accommodation, and the creation of a chamber for a new aerial

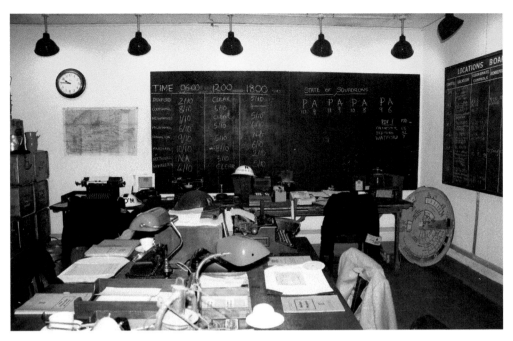

The District Control Room.

array. However, political decisions overtook the fruition of these plans and the proposed extension of the bunker never took place.

By 1966 the Labour government found itself in the midst of a balance of payments crisis with all government expenditure coming under scrutiny, particularly in matters of civil defence. The conventional wisdom was that the scale of destruction as a result of a nuclear attack would overwhelm the civil defence services and that any increase in their capabilities could only be achieved at an unacceptably high cost. With this in mind, the whole concept of civil defence was now called into question. As a result, the Civil Defence Corps was reduced in numbers and its provision of rescue, ambulance, first-aid and welfare services eliminated. The corps was now to concentrate on providing effective communication and control services with local authorities being pressed to provide volunteers from their own staff for civil defence purposes to reduce the numbers of Civil Defence Corps personnel required. In Gravesend council and library staff were given communication and control training at the bunker and by 1967 the council were providing most of the staff for the manning of the control centre and warden posts with Civil Defence Corps personnel only being used where absolutely necessary.

More civil defence responsibilities were soon being transferred to local authorities and the regular public emergency services leading, in 1968, to the disbandment of the Civil Defence Corps, the closing of its training centres and the disposal of its vehicles and equipment.

Kent County Council remained responsible for civil defence emergency measures and continued maintaining the County Control Centre at County Hall. The Woodlands Park

bunker at Gravesend was retained as a designated Sub-Control with its equipment intact, heating and ventilation maintained on timing controls, and was cleaned weekly, ready for reactivation at any time. However, this 'stand-by' status ceased in 1975 and the bunker was then cleared of all its movable equipment.

The bunker continued in use as a store for local historical artefacts and for part of the Gravesend Library collection as well as providing archive space for Gravesham Borough Council.

In 1995 a local history group, the New Tavern Fort Project (now known as Thames Defence Heritage), received permission from Gravesham Council to undertake restoration of the bunker and open it to the public. Then followed work on acquiring the appropriate furniture, equipment and fitments to restore most of the interior of the bunker to an authentic state as a 1960s Civil Defence Control. In addition, a small area was used to create a 'mock-up' of a Royal Observer Corps 'Cold War' monitoring post.

The bunker was ceremonially opened as a museum on 18 September 2004 (the 50th anniversary of the year of its construction). Unfortunately, several instances of flooding caused the bunker to be closed in 2014 and its contents removed to storage whilst remedial works were undertaken by the council. The bunker was eventually reopened in 2018 and is once again receiving groups for guided tours.

The bunker's emergency exit.

Royal Observer Corps – Underground Monitoring Posts in Kent and No. 1 Group HQ, Maidstone

The Royal Observer Corps had its origins in the First World War. With the south-east of England suffering bombing raids by German Zeppelin airships and seaplanes, the requirement for an early warning system became urgent. A network of observation posts was formed, manned at first by army personnel and later by police special constables who would report any spotting of hostile aircraft activity to the relevant military authority.

By 1917, an increasing number of fixed-wing aircraft, including twin-engined, heavy 'Gotha' bombers, were being deployed on bombing missions over England with London taking the brunt of these actions. The task of countering these raids was made the responsibility of Major-General Edward Ashmore, a former Royal Flying Corps pilot who had recently commanded an artillery division on the Western Front. Ashmore reorganised London's air defences and formed the Metropolitan Observation Service which met with some success in spotting enemy aircraft on their way to the capital.

Following the end of the war, the Metropolitan Observation Service was disbanded. However, in 1924 a new Air-Raids Precautions Committee was formed under the aegis of the Air Ministry. Maj-Gen Ashmore was called to report to the new committee and tasked with conducting a series of experiments, using special constables, to observe, plot and report on an aircraft flying a random course over nine observation posts in the Weald of Kent. Ashmore set up his HQ in the village post office at Cranbrook and conducted a successful series of day and night observation tests. The following year, the trials were extended to include parts of Essex and Hampshire. The further success of these trials proved the system to be feasible and a new organisation to be known as the Observer Corps was established on 29 October 1925.

The new corps initially operated from posts in the south-east of England which were divided into four 'Groups' covering much of Kent, Sussex, Hampshire and Essex with the intention that a total of eighteen groups would eventually cover the whole of Great Britain. The headquarters of No. 1 Group was established at Maidstone. The reporting system relied on the co-operation of the RAF, Army, Police and the GPO (who operated the national telephone network). Recruits were spare-time volunteers who received neither pay, uniform, nor allowances. Control of the Observer Corps was placed in the hands of the county police forces and new recruits were enrolled as special constables. Each observation post was manned by a sergeant and six special constables. In 1929 the control of the Observer Corps passed from the county police forces to the Air Ministry, although chief constables retained responsibility for personnel and recruitment matters.

Members of the Observer Corps played a major part in the air defence of Great Britain during the Second World War, spending many long hours in simple open wooden structures listening for the sound of approaching enemy aircraft, aided only later in the war with electronic listening devices. These soundings had to be confirmed visually using long-range binoculars and simple mechanical tracking devices. Confirmed sightings were transmitted by telephone from the Observer Posts to Group and Sector Controls where they were co-ordinated with plots from radar stations. As a result of their role during the Battle of Britain, in April 1941 the Observer Corps was granted the title Royal by

King George VI, and the Royal Observer Corps (ROC) became a uniformed civil defence organisation administered by RAF Fighter Command.

Following the end of the war with Germany, the corps was disbanded on 12 May 1945. However, less than two months later, on 7 July, the Chiefs of Staff Committee identified a continuing requirement for an Observer Corps, albeit in a modified form, until a viable electronic early warning system could be established. It was a further eighteen months before active training of the re-formed ROC began in January 1947 and a year later it was operating from 1,420 posts and thirty-nine centres. Most of the observation posts still dated from the Second World War and offered little protection against the weather for the volunteer observers so, in 1951, Orlit Ltd of Colnbrook in Buckinghamshire were contracted to supply prefabricated sectional shelters for use as observation posts. These provided a weatherproof cabin with an adjacent open observation area and were either laid directly on the ground or raised on concrete legs, depending on the post's location.

By the mid-1950s the advent of high-speed, high-altitude jet bombers together with the improved performance of radar was bringing the traditional aircraft-reporting role of the ROC into question and its future in the new 'Nuclear Age'. However, the Home Office were now investigating how to record the impact points of a nuclear attack (known as 'Ground Zero') on the country. One result of these investigations was the creation of a national network of 'shadowgraphs' (later known as Ground Zero Indicators or 'GZIs') which were fitted to ROC posts.

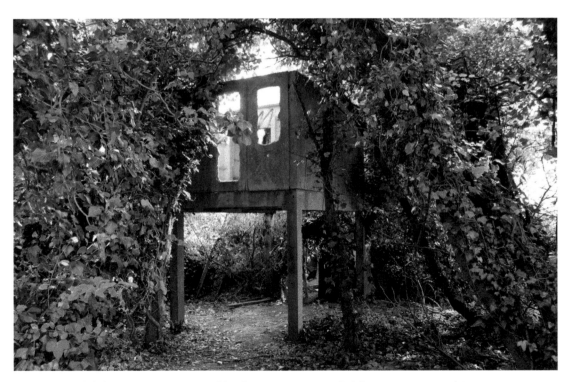

ROC 'Orlit' observation post at Brooklands on Romney Marsh. (Photo: Steve Tanner)

Also, recent tests of the hydrogen bomb by the United States and the Soviet Union had highlighted the dangers of radioactive fallout from a nuclear explosion, and it was realised that many deaths and injuries would be avoided if people could be warned to take shelter before the arrival of the fallout cloud. In response to these concerns, in 1955 the Home Office created the United Kingdom Warning and Monitoring Organisation (UKWMO), combining the Air Raid Warning Organisation with the ROC. Its main responsibilities were to warn of air attack, to confirm nuclear strikes and to initiate public warnings of air attack and approaching radioactive fallout.

The UKWMO possessed little infrastructure of its own, so it relied heavily on the ROC and its existing nationwide network of posts and communications to monitor the passage of fallout. However, it was soon realised that a completely new physical infrastructure would be required to provide the ROC's volunteers with protection from the effects of a nuclear strike. In May 1956, the first detailed plans for an underground ROC monitoring post were finalised and the first prototype was installed at Farnham, Surrey in September

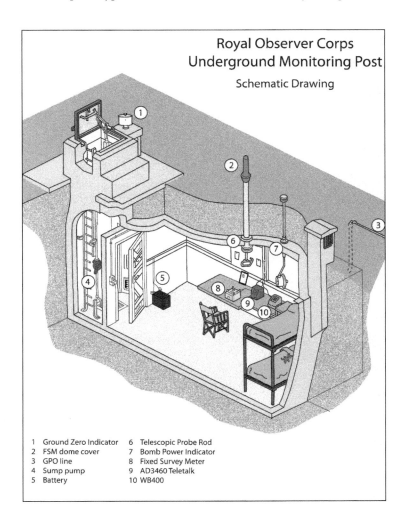

Royal Observer Corps
Underground Monitoring Post

Schematic Drawing

1	Ground Zero Indicator	6	Telescopic Probe Rod
2	FSM dome cover	7	Bomb Power Indicator
3	GPO line	8	Fixed Survey Meter
4	Sump pump	9	AD3460 Teletalk
5	Battery	10	WB400

'Cut-away' drawing of an underground monitoring post.

that year. Subsequently, a further 1,559 similar posts were built across the country, at the cost of around £1,250 each. The posts were built approximately 8 miles apart in a grid system. Wherever possible they were built on the site of old surface visual observation posts to avoid delays and incurring the costs of acquiring new land.

Each four-man underground post consisted of a rectangular reinforced-concrete 'box', approximately 20 feet long, 7 feet wide and 7 feet high internally. The concrete roof slab was 7.5 inches thick and covered with at least 3 feet of earth. The 'box' was divided into two chambers. It was accessed by a fixed ladder, down a 15-foot-deep, 2-foot-square vertical shaft set in one corner of the structure. At the base of the shaft there was a concrete drainage sump let into the floor. The sump was emptied by means of a rotary hand-pump fixed to the wall which pumped the excess water up an outflow pipe to the surface. Also, at the foot of the shaft were two doorways, one giving access to the main monitoring room chamber, and the other to a store cupboard which also housed an 'Eltex' chemical toilet.

A ventilation shaft ran from the surface down to a vent in the store cupboard. A second ventilation shaft ran from the surface to the rear end of the Monitoring Room. Both ventilation shafts were fitted with protective louvres to deflect debris away from the shaft entrance. The entrance shaft was fitted with a steel hatch cover which could be locked when the post was not in use.

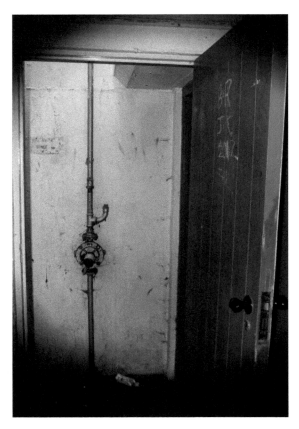

Sump hand pump in the monitoring post at Hoo St Werburgh.

Chemical toilet in the monitoring post at Swingate.

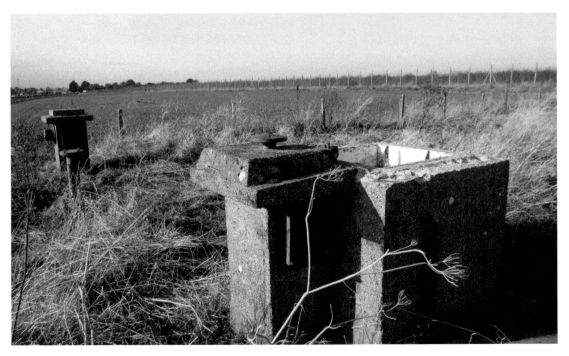

Entrance hatch to the monitoring post at Minster in Thanet.

The Monitoring Room was furnished with a double bunk bed and one single bed, canvas chairs, a folding table, a store cupboard, instrument shelf and a battery rack to hold the post's power supply. Lighting was provided by a single bulb or fluorescent tube which was powered by a 12-volt car battery. The batteries were recharged using a petrol-driven charger. In some posts the batteries were later replaced with portable generators.

The main method of communication within the ROC was by landline telephone and the posts had dedicated private circuits to the local exchange. In the event of a landline failure, at least one post in every area was provided with a VHF radio set which they could use to communicate with Group HQ.

In an emergency, food would be issued in military ration packs. Food and water reserves held in the posts were sufficient to sustain the crews for a week. The posts were equipped with three main instrument sets: the Fixed Survey Meter (FSM), which was the principal radiation measuring device; the Bomb Power Indicator (BPI), which measured the peak overpressure of a nuclear bomb blast wave as it moved over the post; and the Ground Zero Indicator (GZI), which recorded the direction of the initial thermal 'flash' of a nuclear explosion. The FSM remained inside the post and was connected to an ionisation chamber by a telescopic rod. The ionisation chamber would be raised to the surface through a large-diameter pipe in the ceiling of the Monitoring Room. At the surface a PVC cover protected the FSM pipe, sealing it from the elements.

The BPI consisted of a pair of circular steel plates attached to a galvanised steel pipe. The plates formed a casing for a bellows. The pipe passed through the roof of the post, into the Monitoring Room where it connected to the indicator unit. If a nuclear device

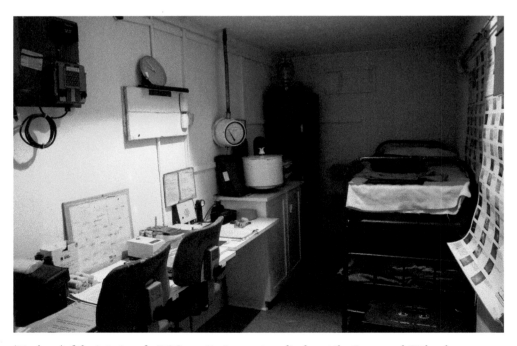

'Mock-up' of the interior of a ROC monitoring post on display at the Gravesend CD bunker.

detonated, the bellows in the casing would be expanded by the blast, forcing air down the pipe which turned a spindle which in turn rotated the needle on the indicator unit.

The GZI was mounted on the surface, near the entrance hatch. It consisted of a cylindrical pinhole camera with four pinholes, each facing a cardinal compass point. Internally, it was divided into four segments, each of which had a transparent plastic pocket marked off in graduations in degrees of bearing and elevation. A piece of photographic paper was placed behind it. In the event of a nuclear explosion the image of the burst would be burnt into the paper. One of the Observers would then have the task of climbing outside the post to retrieve the paper. The bearing and height of the explosion would be transmitted by telephone to Group Headquarters where, by triangulation of readings from several posts, the exact location of the explosion could be determined, and the direction of fallout clouds predicted and plotted.

Fortunately, the call-out to man the posts for real never happened and so they were never used for their intended purpose, but the crews continually practiced and trained to be ready if a war situation arose.

In 1968, the financial crisis facing the Labour government caused the announcement of huge cuts in the home defence budget which resulted in the closure of 686 of the underground ROC posts. However, the resurgence of the Cold War in the 1980s saw the Conservative government increase the budget which allowed for the modernisation of the Emergency Communications Network and the replacement of some outdated equipment within the remaining posts.

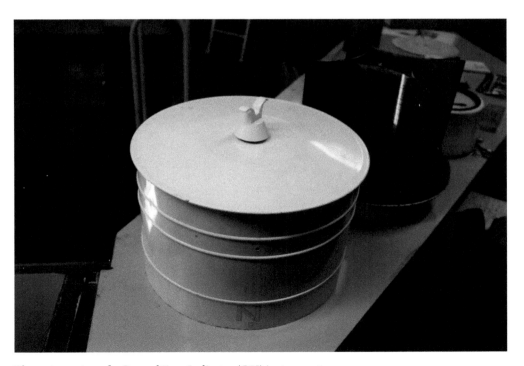

The outer casing of a Ground Zero Indicator (GZI) instrument.

In May 1991, following the end of the Cold War and the perceived end of the nuclear threat to this country, the government announced that the UKWMO was to be disbanded and the ROC stood down. Training ceased in July, and the ROC's operating role ended in September. All the underground posts were cleared of their equipment and abandoned. The majority of them were then demolished but a significant number remain in place in various states of decay. A few have been purchased by enthusiasts who have restored them and, in some cases, opened them to the public.

Forty-nine underground ROC monitoring posts were built across Kent, which came under No. 1 Group with its HQ at Maidstone. Few now survive but some good examples can still be seen at Hoo St Werburgh, Swingate, Minster (Thanet), Crete Road Folkestone and Dymchurch. Of those that survive most have been locked and sealed, and some have had their entrance shafts blocked. Very few are accessible with any degree of safety.

At the outbreak of the Second World War, Fairlawns, a large property on the London Road in Maidstone, was requisitioned for use as the new headquarters for No. 1 Group of the Royal Observer Corps. It continued in use until the end of the war, when its status was reduced to a training centre for the ROC 19 Group Control at Beckenham.

Following a revision of the ROC's Group structure in 1953, which saw the number of Groups reduced from thirty-one to twenty-nine, Beckenham and Bromley were absorbed into No. 1 Group with the Group HQ re-established at Fairlawns.

The United States had tested the world's first hydrogen bomb in 1952. This was followed just a year later by the first Soviet H-bomb test. But it was not until the US ran a further series of H-bomb tests at Bikini Atoll in the Pacific in 1954 that the terrible consequences

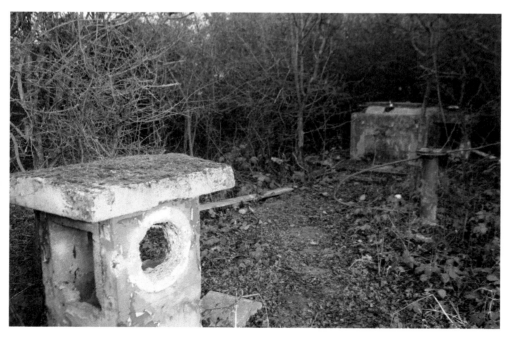

Hoo St Werburgh.

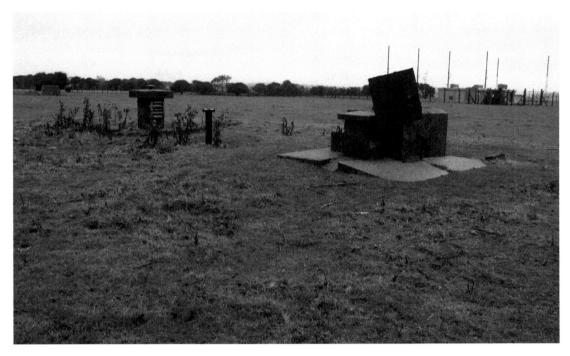

Swingate.

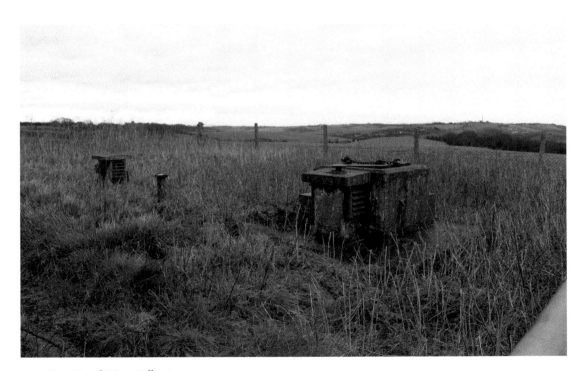

Crete Road West, Folkestone.

Dymchurch.

of nuclear 'fallout' first became appreciated. The results of these tests showed that many thousands more would die slowly from the secondary effects, irradiated by clouds of radioactive fallout, than would be killed instantly by the initial blast.

As a result of these findings the British government in meetings with the Defence Staffs agreed to investigate the establishment of a joint fallout reporting organisation. It was originally proposed that the Civil Defence Corps undertake the reporting role, but this proposal was rejected by the RAF and the Home Office. Consideration was then directed to the Royal Observer Corps. The ROC had long experience in the reporting role going back to the 1920s and still maintained much of the infrastructure to support that role.

The Home Office team charged with the set-up of the fallout organisation initially considered that fallout reporting would assume a secondary function to the ROC's traditional role of aircraft reporting. However, increasing awareness of the extent of the fallout threat soon changed these priorities and by 1956 the Home Office was lobbying for the provision of fully hardened and radiation-proof accommodation for the ROC.

By 1956 it was realised that, as well as a network of new underground monitoring posts, the provision of hardened accommodation would need to include Sector and Group headquarters. Some locations were able to adapt existing suitable buildings such as, by now redundant, anti-aircraft operations rooms and former RAF sector operations rooms. However, such buildings were not available in all HQ locations, so new structures had to be designed and constructed to serve these. Financial approval was eventually granted for the new construction programme to commence in June 1959.

The first of the new headquarters to be completed was that for No. 1 Group at Maidstone in 1960 and it still survives today. The forthcoming official opening of the new headquarters was announced in *The Times* on 10 June that year:

> General Sir Sidney Kirkman, Director-General of Civil Defence, will open the first of a number of specially constructed Group headquarters for the Royal Observer Corps at Maidstone on June 25th.
>
> The R.O.C. for many years the "eyes" of R.A.F. Fighter Command in an aircraft spotting role, now has responsibility for reporting nuclear fall-out, and the new buildings have been designed to allow members of the Corps to operate for long periods, completely self-contained, in the event of a nuclear war.
>
> Maidstone will be the headquarters of No. 1 Group R.O.C. ...
>
> The new air conditioned headquarters at Maidstone consist of an Operations room, Officers Dormitories for men and women, Contamination-cleansing rooms, a Kitchen and Canteen, Training and Storage rooms.
>
> The walls are furnished in a coating of anti-condensation material.
>
> The functions of the nuclear-age headquarters would be to receive and coordinate information of fall-out from the Posts they control and from other Groups and pass it on to the Civil Defence authorities, the services and other interested organisations.

The semi-underground bunker was constructed in the grounds of the existing HQ building at Fairlawns and was built on three levels.

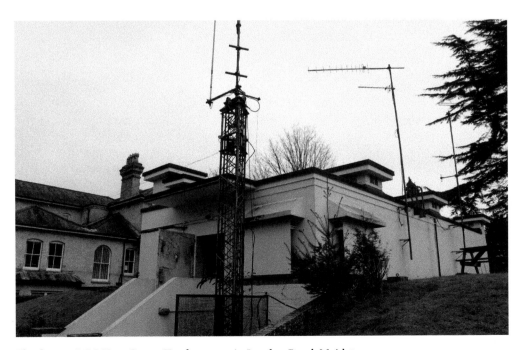

The former ROC No. 1 Group Headquarters in London Road, Maidstone.

The upper level comprises a raised, windowless, reinforced-concrete surface blockhouse which contains the main entrance portico accessed via a set of steps up a mound. All the exposed concrete surfaces were painted white to reflect the heat from nuclear flashes. Other external features include the mounting for a 'Ground Zero' indicator (GZI): a circular metal box in which four pieces of light sensitive paper could be positioned, creating four shadowgraphs or rudimentary cameras which would have been used to record the height and position of bomb bursts, the same instrument as used on the underground monitoring posts. A telescopic lattice girder radio mast provided means for wireless communications.

Access to the bunker is through a steel blast door into a short corridor with a gas-tight door which forms an airlock. This level also houses the air-conditioning filter room and the decontamination centre.

The middle level is partially underground, covered by a soil and grass mound and is accessed internally by a stairway down from the upper level which leads into a central corridor. At the bottom of the stairs, the first room on the right houses the ventilation and filtration plant. All the plant remains in place and in the corner of the room another gas-tight door leads into a separate filter room. At the rear of the room two wooden doors open into the generator room. This level also houses the kitchen, canteen, male and female toilets and dormitories, officers' room, the GPO (later BT) equipment room and the sewage ejection plant.

The final two doors on the right-hand side of the corridor lead onto the balcony which overlooks the control room on the lower level. At the end of the corridor there is a gas-tight

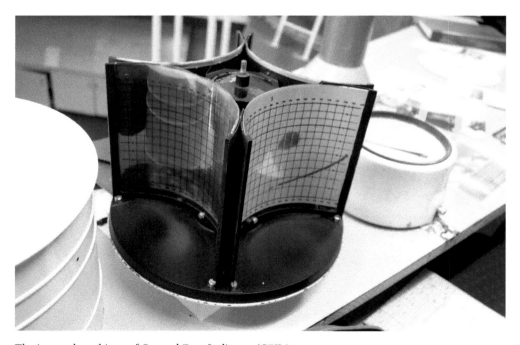

The internal workings of Ground Zero Indicator (GZI) instrument.

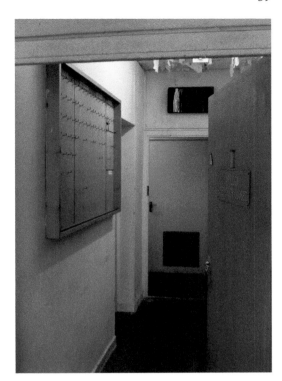

Right: Entrance airlock at the Maidstone Group HQ.

Below: The ventilation plant.

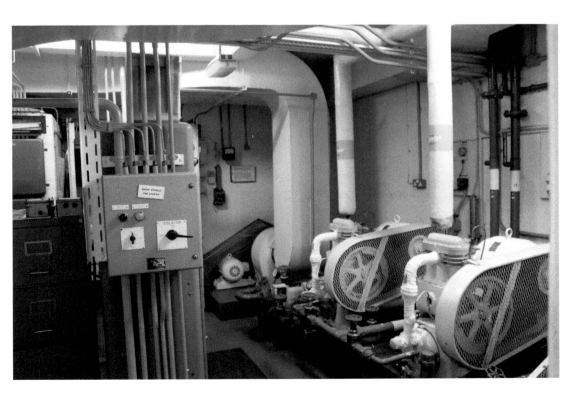

Kitchen.

door with another one beyond giving access to the emergency exit. These two doors form a second airlock. A ladder on the wall leads up to a landing and then a second ladder up to the emergency escape hatch. This was replaced in the 1970s by a stairway with a door on the south side of the mound.

The lower level was the working hub of the HQ: the control room together with the adjacent communications room. Three small windows look out from the communications room into the control room with a small message hatch beneath one of them. A ladder leads up from the floor of the control room onto the roof of the communications room from where another ladder leads up to the observation balcony on the middle level. The command table and most of the other original furniture, fixtures and fittings have been removed from the control room but a large floor-standing display board and cupboard remain.

The HQ required around fifty people to staff it, made up from around forty ROC personnel and ten Home Office warning and scientific officers, split into three watches: duty, standby and rest.

During active operations in the control room the triangulation team would analyse the information received from individual ROC monitoring posts. This three-man team consisted of a tote-operator, a triangulator and an assessor. The burst times, pressure readings, elevations and bearings from each post were shown on a blackboard. Bearings from the post were plotted on a table map, which gave a triangulated fix on ground zero. With the aid of a calculator, the pressure readings and distances enabled the scientists

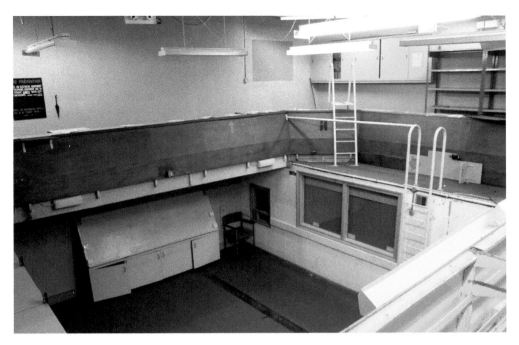

Balcony overlooking the Control Room.

to calculate the power of the bomb or bombs. This and other information were then passed to the Sector Operations Centres of the United Kingdom Warning and Monitoring Organisation (UKWMO) where more scientists were able to predict where and when the fallout was heading. There were 5 Sector Operations Centres, four in England and one in Scotland, located within Group Headquarters.

In the centre of the control room was the command table at which the duty controller and senior warning officers would sit. From there they could view the nuclear burst tote board and situation map displays. The display plotters and tellers were situated on opposite sides of the balcony. The plotters would use chinagraph pencils to update the Perspex-covered display boards.

Although the bunker was connected to all mains services, it was designed to be self-sufficient for up to thirty days under emergency conditions for which it was equipped with a stand-by generator, air-conditioning plant, emergency water tank, bulk fuel storage tank and a sewage ejection system.

The bunker continued in use throughout the rest of the Cold War period, ready to deal with any nuclear attack whilst conducting regular emergency exercises and personnel training. In 1976 Fairlawns, which was still being for administration purposes, was renamed Ashmore House in memory of the corps' founder, Major-General Edward Ashmore.

Following the end of the Cold War and subsequent stand-down of the ROC in 1991 Ashmore House and the bunker were sold to a firm of local solicitors in whose ownership they remain today. The bunker has been very well maintained and is in excellent condition, as is all the plant machinery.

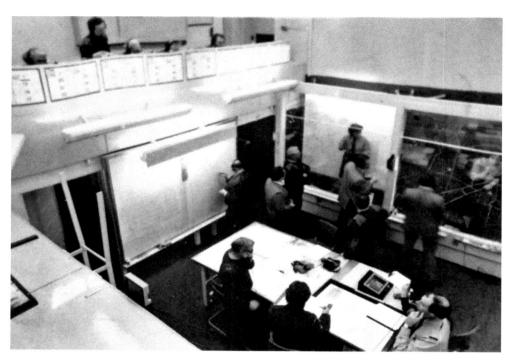

No. 1 Group HQ Control Room operating in the 1980s.

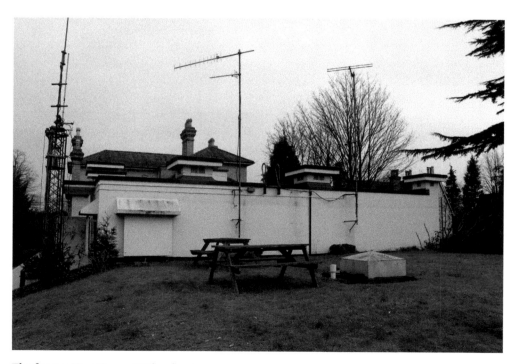

The former No. 1 Group HQ bunker in 2017.

Dover Castle Regional Seat of Government

During the Napoleonic Wars (1797–1810), tunnels were excavated in the cliffs under Dover Castle to form a series of casemated (bombproof) barracks to house several hundred soldiers. They were then used in the First World War as offices and stores and in the Second World War they were used by all three services but predominantly by the Royal Navy when they became the HQ of the C-in-C Dover, Vice Admiral Sir Bertram Ramsay. It was these tunnels, designated 'Casemate Level', that Ramsay conducted Operation *Dynamo*, the evacuation of the British Expeditionary Force from Dunkirk in June 1940.

In the Second World War, another two levels of tunnels were excavated under the castle to house a new underground hospital (later designated 'Annex' Level) and a forward Combined Headquarters (CHQ) for all three military services.

The tunnelling for the CHQ was carried out by 172 Tunnelling Company and 693 Artisan Works Company of the Royal Engineers. The new CHQ was code-named 'Bastion'. Work commenced in early 1941 to extend the existing underground complex. The new excavations were carried out above and to the rear of the Royal Navy's facilities in the Casemate Level tunnels and were over half completed when the work had to be abandoned due to severe subsidence.

In late 1942 the work recommenced but at a much lower level, excavating a new complex of tunnels and rooms. Spoil from the works was tipped out through a hole

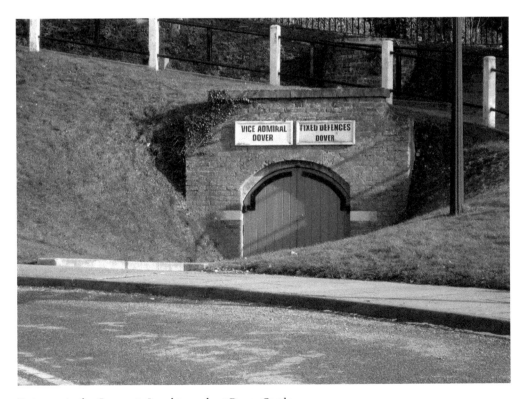

Entrance to the Casemate Level tunnels at Dover Castle.

Entrance to the Annex Level tunnels at Dover Castle.

made in the cliff face. After the tunnellers had finished their work they were followed by around 250 tradesmen of No. 693 AW Company, Royal Engineers. They included masons, bricklayers, electricians and plumbers. By early 1943 this work was completed, and the complex had been fitted out to form a complete joint headquarters designated 'CHQ Level'. It was fully equipped with a back-up power generator and an air-conditioning system. Written communications within the complex were made using a Lamson vacuum tube system. The new HQ was connected, by telephone, via an extensive network of cables to the various coastal gun and anti-aircraft gun batteries, brigade HQs, airfields and naval establishments in the Dover area.

After the war, the CHQ was closed and the tunnels were cleared of most of the equipment and furniture. However, the increase in the tensions of the 'Cold War' following the Berlin Crisis of 1948 saw the reactivation and updating of some of the country's wartime radar stations and an Anti-Aircraft Operations Room (AAOR) was opened in the tunnels under Dover Castle, utilising the former CHQ complex and the Admiralty's 'Casemate Level' tunnels. The role of the AAOR was to co-ordinate the area's anti-aircraft gun defences with the Ground Control Intercept (GCI) Radar Station at Sandwich and the RAF Sector Operations Centre (SOC) at Kelvedon Hatch in Essex. New blast-proof steel doors were installed at the entrances and exits, and steel plates fixed to the grills of the ventilation shafts for added protection. Inside, the operations room was overlooked by a balcony on three sides, fitted with curved Perspex glazing, giving a clear view of the plotting table below. Corridors around the outside of the room provided access to various offices and cubicles.

Right: Tunnelled corridor in the Second World War Combined Headquarters.

Below: The site of the former Dover AAOR Operations Room *c.* 1990. (Sub Brit Collection)

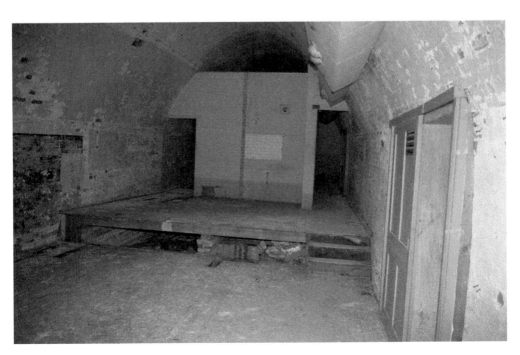

The lower-level tunnels housed a generator, to provide emergency electrical power, and ventilation plant. The AAOR was staffed by army personnel who were tasked with filtering information from the SOC to the individual AA gun sites. The Dover AAOR continued in operation until the army's Anti-Aircraft Command was disbanded in 1955. The tunnels continued to be used by the Royal Navy until the Admiralty abandoned its headquarters here and, together with the remaining army garrison, vacated the castle in 1958.

By the mid-1950s the entire system of UK wartime contingency planning had been completely revised. With the Soviet Union now in possession of the hydrogen bomb, they now had the power to destroy whole cities together with all surrounding transport and communications infrastructure. The devastating power of a thermo-nuclear strike now meant that there was no longer the possibility of providing adequate shelter for the civilian population so the requirement would be to deal with the prospect of millions of irradiated and displaced people as well as similar numbers of dead and injured.

Even if a region was not physically affected by blast, fallout would affect people's ability to move about, refugees would be a problem, the national distribution system for food and other essentials would have broken down, there would be no imports of food, the national electricity grid would have been put out of action, there would be no effective national leadership and underlying everything would be a sense of confusion, despair and fear for the future.

The consequential breakdown in communications between central government and the regions meant that each Region would need to act as an autonomous authority until national government administration could be restored. The Regional Commissioner (usually a senior government minister), appointed by the government in the name of the Crown, would assume the mantle of central government authority within his Region. To fulfil this role a large staff would be required, in effect a 'mini Whitehall', to mirror most of the domestic Departments of State. The Regional Commissioner would also have ultimate authority over his local military commanders and would be empowered to use their forces as he saw fit, either for defence against external enemies, to implement sanctions or to suppress internal dissent, as well as assisting with relief work.

The existing chain of Regional War Rooms were deemed inadequate to meet the new requirements, so to support the Commissioners in their new extended roles a new form of regional headquarters known as Regional Seats of Government (RSG) was planned. However, cuts in the 1957 defence budget meant that any concept of new, purpose-built structures had to be abandoned. Instead, in 1958, it was proposed to adapt suitable existing buildings, where available, and repurpose them to serve as RSGs. In the short term some existing war rooms were retained including the No. 12 (South Eastern) Region War Room at Tunbridge Wells, but between late 1958 and mid-1961 several suitable alternative sites were identified, including the wartime underground tunnel complex at Dover Castle.

In 1958 the Dover Castle tunnels were handed over to the Home Office for adaptation into one of ten new proposed emergency Regional Seats of Government sites receiving the designation RSG 12. Its purpose was to provide secure accommodation for the Regional Commissioner, together with his staff and military advisors, as well as a system of administration and supply during and following a nuclear attack. The Dover RSG was

designed to accommodate and sustain up to 450 essential personnel for several weeks. The staff were split into five main functional groups: units from various ministries, public information services (including the BBC), the police and fire services, civil defence control, and communications. The Regional Commissioner, the Deputy Regional Commissioner and the Principal Officer, supported by a Secretariat, would form the nucleus of the RSG. A combined operations staff, scientific advisors and legal advisors would be on hand to provide additional support to the nucleus. Under them would come the representatives of the various departments involved in home defence: the uniformed services (military, fire, police and civil defence) together with a large supporting staff.

The RSG also had a Camp Commandant who would be responsible for the building and its physical facilities. His initial task was to prepare the site, allocate rooms to the various uses, and acquire furniture and rations where necessary.

The Camp Commandant would also be responsible for security and reception of the staff. The majority of the RSG staff would have had no idea of their wartime role until they received a letter from their personnel department telling them. A draft call-up letter in a Ministry of Health file informed the recipient that they had been 'selected for duty at an important wartime HQ. So far as anyone can say at the moment you may be there for about a month'. The letter told the civil servant to go home immediately and pack their personal effects. They were warned that they would have to do their own washing but 'clothing may be informal' and as entertainment would be limited, they should take

RSG 12 Camp Commandant's Room.

some books. They could draw up to £25 in advance of their salaries but should make arrangements for their salary to be paid to their spouse. Apart from this there was no mention of what their families should do. The staff would be instructed to arrive at the RSG independently or in small groups. Some staff would come from London whilst others would have come from regional offices of their departments. Many of the junior staff would have come from local offices of central government departments.

The lowest tier of tunnels at Dover, now designated 'DUMPY Level', became the communications and operations centre of the RSG and housed the various government departments. DUMPY was modernised and fitted out with new communications equipment, modern air-filtration plants and generators.

A complete BBC studio was also installed to enable radio broadcasts to be made to those who had survived the initial nuclear assault above ground.

The old spiral staircase entrance down to the tunnels was sealed at the top with a concrete cap as a precaution against nuclear contamination. The main access was now via a lift from a new, purpose-built entrance block, near the castle's Officers' Mess, which was faced with stone to blend in with its far older surroundings.

Space was found for large reserves of food, fuel and water. Once the mains supply had been cut following nuclear attack water would be taken from a buried 24,000-gallon-capacity storage tank with pipework connected to Casemate and Dumpy levels.

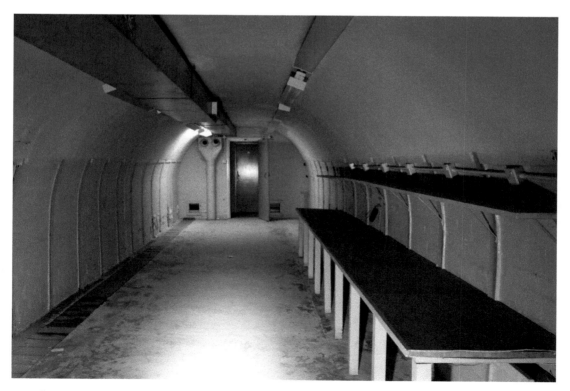

Communications Room.

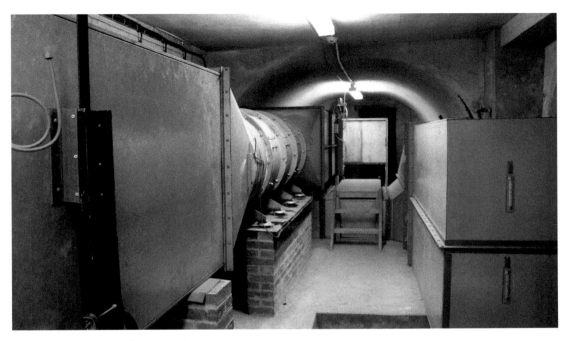

DUMPY Level air filtration plant.

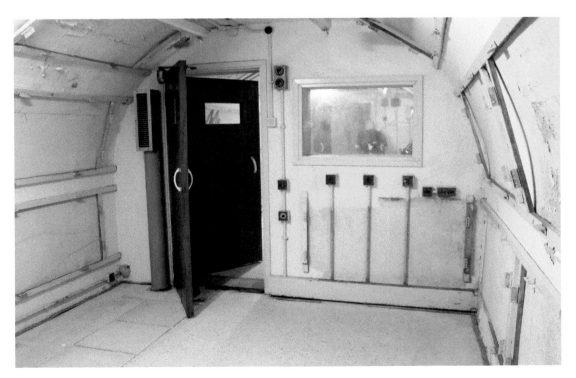

The BBC studio.

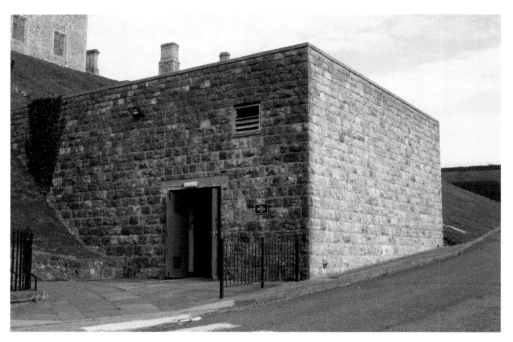

RSG 12 entrance block.

DUMPY Level washroom.

There was also a buried 10,000-gallon-capacity tank feeding a secondary distribution system via a 4,800-gallon tank at the top of the emergency staircase from Annex level. The higher tunnel levels were used as stores and a canteen and were also fitted out with new dormitories, restrooms and a kitchen. Although the new RSG was meant to be top secret, its existence inevitably soon became known to many of the local Dover residents!

Even before this refurbishment had been completed, the system for emergency government was changed again. In early 1962, the Home Office realised that reorientation of the RSG structure towards a more central government role had removed the link, previously maintained by the Regional War Rooms, between Whitehall and local authorities Civil Defence Control Centres. To reinstate that link an intermediate level of control, the Sub-Regional Headquarters (SRHQ), was developed. Each Region was divided into two or three Sub-Regions with the creation twenty-five Sub-Regional Headquarters (SRHQs). The old Regional War Room at Tunbridge Wells was designated as one of the Southern Region SRHQs.

In 1965 the recently elected Labour government, now in the midst of an economic crisis, ordered a fundamental review of home defence. The review concluded that because of the precarious economic situation future civil defence preparations would have to be 'restricted to measures which would be likely to make a really significant contribution to national survival'. As a result of the review the idea of a permanent RSG that would be manned before an attack was abandoned in order to give more flexibility to the control system. The plan now would be to focus on a network of permanent Sub-Regional Controls (SRCs) rather than a network of RSGs. Many RSG sites were repurposed into SRCs, including Dover Castle which was designated SRC 5.1. The RSGs would still exist as an administrative control but would only be initiated within the SRC sites as and when central regionalised government control was required.

The SRCs would provide help and assistance to local authorities; provide a link to and assist utility organisations (electricity, gas, water, communications, transport, etc.) in the maintenance or resumption of power and water supplies, transport of food and other essential services; and to assist in the overall command and control of the armed forces, police, fire and medical services.

The structure of emergency Regionalised Government was reorganised once again in 1973 with a reappraisal of the Home Defence Regions. New Defence Regions were established based on the old Sub-Regional structure but with a reduction to seventeen SRHQs. Dover was designated as SRHQ 6.1. and remained in use until the late 1970s when, just yet more new work was due to start on the site, the decision was taken to move operations to a new Regional Government Headquarters at Crowborough in East Sussex.

The Home Office finally abandoned the Dover tunnels in 1986 and handed them over to English Heritage. The upper levels (Annex and Casemate) have been opened to the public for some years now but 'Dumpy' remains off limits due to health and safety concerns except for occasional, specially organised small group visits.

Above and below: Redundant RSG communications equipment awaiting disposal to museums.

HMS *Wildfire,* Maritime Local Command Headquarters – Gillingham

In 1937, with tensions rising in Europe over the territorial ambitions of Nazi Germany, the British government adopted a policy of providing protected combined headquarters accommodation for all three armed services at the four main naval ports of Portsmouth, Plymouth, Chatham and Rosyth. In March 1938, the Admiralty wrote to C-in-C of the Nore Command, Vice Admiral Sir Edward Evans, to inform him that an Area Combined Headquarters (ACHQ) would be established at Chatham which would house the Commanders of the Naval and Air (No. 16 Group RAF Coastal Command) Forces operating in the area and at which the Commander of the local Army forces would also be represented, either by a Military Liaison Officer or, if circumstances demanded, by the Army Commander himself.

Discussions between the three local Commanders soon commenced and by May 1938 they had identified three possible sites for the ACHQ. As Chatham Dockyard was considered to be a prime target for enemy bombing in time of war, the preferred site was one around 2 miles distance from the dockyard which would consist of several bomb splinter-proof surface buildings and would be, to a great extent, camouflaged by the building of small houses currently going on around the site. It also had the advantage, from the RAF point of view, that it was relatively close to the civil aerodrome at Rochester. However, it was also acknowledged that a project for forming an underground Combined Services Operations Block and Group Headquarters on or near the Great Lines at Chatham had been put forward by the Army Commander Chatham Area. The main objection to this suggestion was that the Group HQ and Operations Block would both be within the main target area at Chatham.

Despite this objection the decision was taken to construct the ACHQ underground on the Lower Lines, close to the Chatham Naval Barracks and the Nore C-in-C's Residence at Admiralty House. The Lower Lines were a series of dry moats built in 1804 as an extension to the Great Lines which served to defend Chatham Dockyard from landward attack.

By March 1939 plans for the new ACHQ had been drawn up with costs estimated at £24,000. The costs would to be divided up between the three services according to their respective areas of occupation with the Navy taking 51 percent, the RAF 45.5 percent and the Army 3.5 percent. The contract for construction was awarded to the Francois Cementation Company and work commenced in May 1939.

Just weeks into the construction it was considered necessary to lower the levels of the ACHQ to obtain the maximum possible cover of chalk consistent with remaining at a safe distance above the standing level of groundwater. It was also found necessary to modify the general layout of the underground offices to meet revised requirements of the Naval and Military staffs and a short length of tunnel was added to accommodate an auxiliary generating plant. The RAF also requested the floor of the Plotting Room to be lowered to provide a better view of the plotting table from their observation cabins.

At the same time the opportunity was taken to modify the arrangement of entrances to give access from the adjoining moat.

By June, the project and costs were being revised further to accommodate the inclusion of a separate teleprinter room that was to be built in the moat. This would provide a connection to the recently established Defence Teleprinter Network. The

cost of the Teleprinter Room was estimated at £1,200 and the ACHQ cost estimate had risen to £25,000. The division of costs was also amended with the Admiralty now taking 52 percent, the Air Ministry 43 percent and the War Department 5 percent.

On completion of the tunnels in December 1939, the complement of the ACHQ was sixty Officers and ninety 'Other Ranks' from all three services. The ACHQ was constructed of steel mine hoops under corrugated iron sheeting with interior panelling; the plotting room was much larger with 40-foot-diameter steel segments. The floor level of the tunnels entered the plotting room at first-floor level, requiring steel stairs at each end to gain access to the plotting floor, which was effectively in a pit. A viewing platform overlooked the plotting table at the eastern end. The plotting room originally had three glass-fronted cabins at floor level. However, their position was raised when the work on lowering the floor was completed and the cabins now overlooked the plotting table and the vertical map boards opposite.

In February 1940 arrangements were put in hand for the provision of extra lavatory accommodation and a car park for the use of the ACHQ staff. The estimated costs were put at £1,400 for the lavatory accommodation and £800 for the car park. However, the introduction of WRNS personnel onto the ACHQ staff necessitated a further review in June. The WRNS would require separate accommodation and restrooms. This and other revisions, which included the provision of surface hutted accommodation off the Medway Road for RAF administrative staff and WRNS personnel, as well as a NAAFI,

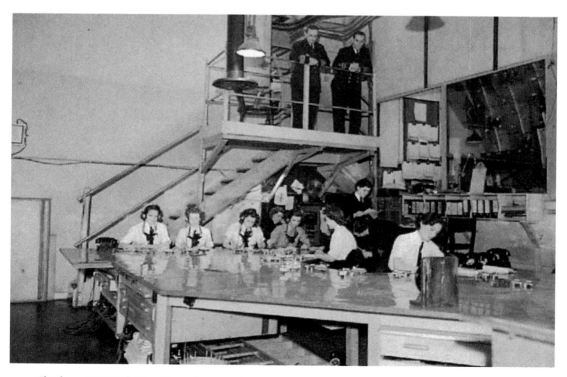

Chatham ACHQ Plotting Room in operation *c.* 1940.

The Plotting Room viewing cabins in 2018.

had increased the overall cost estimate to £36,000. Even though an invasion of the UK was now considered imminent, it did not stop the Treasury expressing its disquiet over the escalating costs which, in their opinion, included work of a 'luxury nature' unjustifiable in war and they considered that the original approved estimates had been 'improperly exceeded'. The criticisms were aimed mainly at the provision of the car park with its cycle and motorcycle sheds. Treasury officials even demanded that the ACHQ staff should be charged for using the sheds. The Admiralty responded by saying that the provision of cycle racks in Royal Dockyards had been accepted as an Admiralty responsibility for many years and was considered standard practice for all good employers. Moreover, many of the ACHQ staff would be arriving during the 'silent hours' when no other form of transport was available to them. The Treasury eventually relented and agreed that no charge should be made for use of the racks. The other cost increases, which included £3,500 for built-in furniture to replace portable furniture due to the lack of space for the latter, and £1,800 for a ramped tunnel connecting to the C-in-C's surface offices, were also accepted as justifiable under the current war conditions.

By November 1940 the ACHQ staff levels had increased to sixty-three officers and 119 other ranks, an increase of over 20 percent. The majority of the personnel were made up of the Commanders, Chiefs of Staff, Staff Officers and advisors together with signals and communications teams and some GPO staff. Both RN and RAF had Wireless Telegraphy (W/T) facilities within the HQ. Two large wooden masts were erected on the surface

above the HQ with the main Nore W/T station around 1.5 miles away, north of the River Medway at Beacon Hill, Chattenden. The Defence Teleprinter Network (DTN) terminal for the entire Chatham area was now located within the new HQ. Written communications within the HQ itself were maintained via a 'Lamson' pneumatic tube communication system whereby messages were rolled into a capsule and inserted into a tube which conveyed it to its destination by air pressure.

Access to the ACHQ was provided by two entrance tunnels, one in the south of the complex from a Nissen hut in the Medway Road Camp and the other from the moat to the north.

The remains of a 'Lamson' pneumatic communication tube.

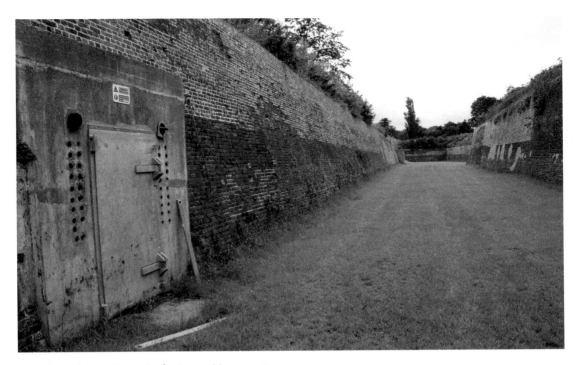

Secondary entrance in the Lower Lines moat.

The secondary entrance tunnel.

An emergency exit was also provided into the moat by way of three vertical ladders up an air shaft from the plant room area.

The ACHQ operated throughout the war and after, into the 'Cold War' period when it took a major part in various NATO exercises. In 1956 the wartime Nissen hut entrance was replaced with a small brick-built entrance building. As a result of the 1957 Defence Review, the Royal Navy's Nore Command was disbanded in 1961 and the ACHQ closed a year later.

As another result of the Defence Review, the Royal Naval Volunteer Reserve (RNVR) was absorbed into the Royal Naval Reserve (RNR). Among the new shore service roles for the RNR were the RNR HQ Units working in Maritime HQs at the major ports. The former ACHQ was an obvious choice for Chatham's Maritime Local Command HQ (LCHQ). During 1962 and 1963 various alterations were made to the internal layout of the site, with additional services such as mains water and, most importantly, sewage disposal. This entailed the construction of a new chamber adjacent to the southern entrance to hold a large water tank; below this a sump was built with sewage ejection equipment enabling the toilets opposite to be connected to the mains and four extra toilets to be provided within the new room.

The naming of the new LCHQ was the cause of some debate within the Admiralty. The Flag Officer Medway proposed that it should be given a ship's name and suggested HMS *Tyrwhitt* as being most suitable. However, when the proposal was put before the Ships' Names Committee it was rejected as it had always been their policy not to use the names of Admirals who had served within 'living memory'.

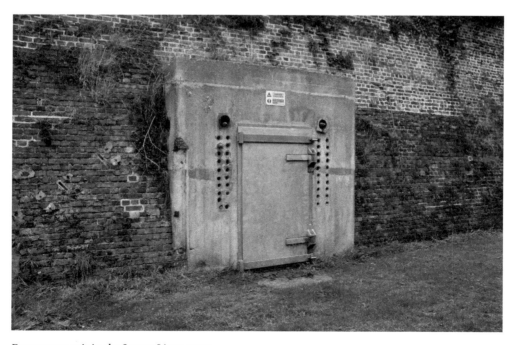

Emergency exit in the Lower Lines moat.

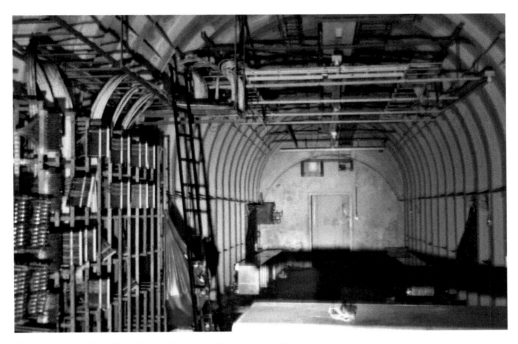

The remains of the Telephone Exchange Room in 2018.

(Admiral of the Fleet Sir Reginald Tyrwhitt had served in the First World War and his son, Admiral Sir St John Tyrwhitt, had only retired from service in 1961.) It was thought, by the committee, that a considerable period of time ('preferably a century') should elapse before such a name should be brought into use. Another suggestion, *Mountevans*, was rejected for the same reason and a third, *Achilles*, had already been reserved for the use of the Royal New Zealand Navy. However, a fourth suggestion, *Wildfire*, was deemed acceptable.

HMS *Wildfire* had been the flagship of C-in-C Nore between 1890 and 1907. More recently it had been the name of the Royal Navy's Shore Establishment at Sheerness during the Second World War and until the base's closure in 1961.

The name HMS *Wildfire* was given final approval on 16 July 1964 and the new Chatham LCHQ was commissioned as such on 10 September 1964 with thirteen Officers and thirty-nine Ratings. The first Commanding Officer was Captain J. S. M. Richardson DSO RN (Rtd), a Commander in the Royal Naval Reserve.

The function of the unit was to provide a trained and stable staff for plotting and communications duties in the Flag Officer Medway's LCHQ in time of war. The reservist Ratings received training in both skills; in addition Officers specialised in Naval Control of Shipping (NCS), Mine Counter Measure (MCM) and Intelligence duties. The tunnels were used for training on drill nights, weekends and during exercises.

When the Chatham Naval Base closed in 1984, the requirement for the Reserve HQ unit ceased and it too closed in 1985 and the LCHQ was vacated and sealed. The surface entrance block was later demolished, and the main entrance tunnel backfilled.

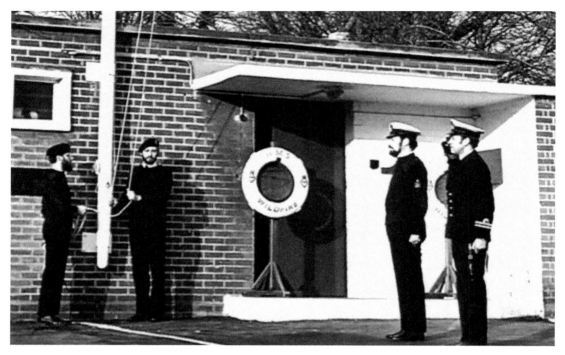

The Main Entrance to HMS *Wildfire c.* 1976.

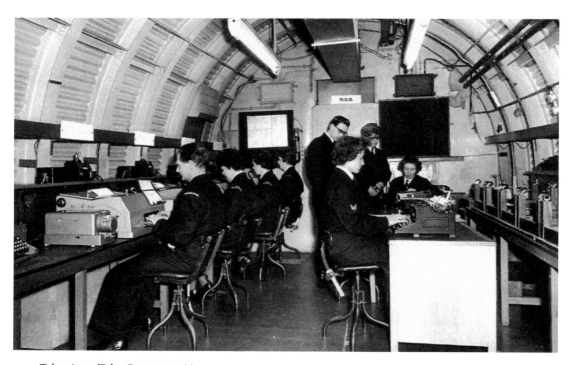

Teleprinter/Telex Room *c.* 1966.

Teleprinter/Telex Room in 2018.

One of the LCHQ Operations Room boards in 2018.

An RNR unit continued to operate at Chatham in the guise of a Communications Training Centre (CTC) based at the Collingwood Block in Khyber Road. The Block had originally been part of the Detention Quarters at the RN's Chatham Barracks, HMS *Pembroke*. The Detention Quarters closed in 1931 and the Block was then used as a Mechanical Training Establishment and later as the Dockyard Training College until the RN left Chatham in 1984. The name HMS *Wildfire* was transferred to the CTC, which continued to operate at Collingwood Block until its closure in 1994. The name HMS *Wildfire* continues to be used for the RNR unit at the Permanent Joint Headquarters at Northolt.

The tunnels on the Lower Lines did not stay sealed for long. Intruders gained access and started a fire in the Operations Room causing some extensive damage to the fabric of the structure. The complex has been accessible a few times for very short periods over the years but, at the time of writing, remains very well sealed.

RAF West Malling

In 1915, a Royal Naval Air Station was established to the north of Maidstone at Detling which was later taken over by the Royal Flying Corps. However, the airfield was often subjected to low hill fog, so an emergency landing strip was established at King Hill, West Malling which could be used whenever weather conditions rendered Detling unavailable.

Following the end of the First World War the emergency landing strip at West Malling was left to become overgrown and all but forgotten. However, with the rekindled interest in private aviation in the late 1920s the hunt was soon on for new potential flying sites. In June 1930, a private company, Kent Aeronautical Services, completed their purchase of the former landing strip site at King Hill and founded the West Kent Aero Club there. In 1932, the aviation pioneer Sir Alan Cobham brought his National Aviation Day Display, more commonly known as 'Cobham's Flying Circus', to West Malling. Within a few years the airfield was sold again and renamed Maidstone Airport. In 1938 the new owner, Walter Laidlaw, was encouraged by the Air Ministry to set up a Civil Air Guard Scheme at West Malling. This was a mainly civilian organisation but was financed by the Air Ministry and run as a military organisation to train possible future pilots for the RAF.

At the outbreak of the Second World War the airfield was requisitioned by the RAF and the first fighter squadrons arrived in 1940. It operated as part of the Royal Air Force Fighter Command's crucial 11 Group protecting the South East and London. For much of the Battle of Britain the airfield was rendered unusable by German bombing. Following extensive repairs, it became a front-line night fighter station.

In 1944 the station was involved in Operation *Diver*, the defence against the V1 flying bomb attacks. By now the airfield had two runways constructed from Sommerfeld Track steel matting and concrete, with Type J and 'Blister' design aircraft hangars.

The airfield was closed at the end of August 1944 and underwent considerable refurbishment. A permanent, 6,000-foot × 150-foot 'hard' runway was laid and the base reopened in June 1945. At the end of the conflict the base was used as a rehabilitation centre for returning Allied prisoners of war.

Post-war, West Malling remained a fighter base with No. 29 Squadron, equipped with Mosquito Mk.30s returning to the airfield that had been its wartime home on 29 October 1945. The squadron's new role was as part of the post-war fighter defence programme.

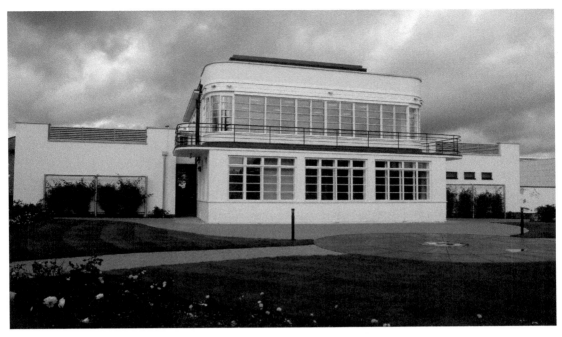

The recently refurbished former RAF West Malling Control Tower (built 1940) in 2015.

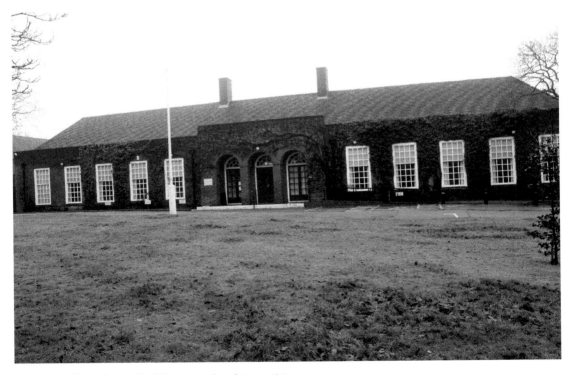

The Officers' Mess (building completed in 1946) in 2012.

In April 1946, 500 (County of Kent) Squadron Royal Auxiliary Air Force was re-formed at West Malling. The squadron was equipped with Mosquito NF36 night fighters crewed by a mixture of Kent-based regular and part-time officers. A new 'T2' Type hangar was later constructed to accommodate the squadron's aircraft.

That same month fifty German prisoners of war were posted to the base where they were set to work, under guard, around various parts of the airfield including the central heating plant and the Station Headquarters. They remained at West Malling for over a year, the last of them eventually leaving in October 1947 much to the relief of the Station Commander, who had been struggling to know what to do with them.

In September 1946, 29 Squadron was joined by another regular unit when 25 Squadron arrived at West Malling equipped with Mosquito NF36 night fighters. They arrived just in time to partake in the Battle of Britain flypast and five squadron aircraft were allocated to the event.

In April 1947 another of West Malling's wartime combat units took up residence at the airfield again. Six Mosquito NF36s of 85 Squadron flew in as a forward party to prepare for the arrival of the rest of the squadron. The new Squadron HQ was made ready and equipment installed in other buildings. By May, 85 Squadron had settled in at West Malling, becoming the fourth resident squadron along with 25, 29 and 500 Squadrons.

During the early period of the Cold War, in the late 1940s and early 1950s the West Malling fighter squadrons were involved in several air defence exercises which highlighted the Mosquito's vulnerability to jet fighters. The East/West tensions over the Berlin Blockade and the outbreak of the Korean War drove the need to re-equip these squadrons with their own jet fighters and from 1948 Vampire and Meteor jets began flying from West Malling.

From July 1948, 500 Squadron commenced replacing their Mosquitos with Gloster Meteor Mk.III jet fighters, but it was a further three years before West Malling's regular squadrons began re-equipping with jets. On 7 July 1951, 25 Squadron's first De Havilland Vampire NF10 night fighters arrived. The squadron was the first in the RAF to be equipped with the NF10. The aircraft had originally been sold to the Egyptian Air Force, but the order was cancelled by the British government due to the worsening relations between the two countries. The NF10 was not a popular aircraft. No two machines were equipped the same and they were considered considerably underpowered compared to the Meteor night fighters.

7 July also saw the arrival of a Gloster Meteor T7 for 85 Squadron, the squadron's first jet aircraft. It was followed on 17 September by three Meteor NF11s, followed by four more a week later. Meanwhile, 29 Squadron remained equipped with its piston-engined Mosquito night fighters until it moved to Tangmere in November 1951, leaving West Malling as an 'all jet fighter' station.

In August 1953, 25 and 85 Squadrons took part in Exercise *Momentum*. Its purpose was to exercise the air defences in interception of Soviet high-level and low-level attacks on targets in the UK and against coastal convoys. The exercise covered most of the United Kingdom and some coastal areas of Northern Ireland. The West Malling night fighter squadrons were kept busy with all types of night raids. The station was placed on an operational footing with guards posted, aircraft dispersed, and lights dimmed.

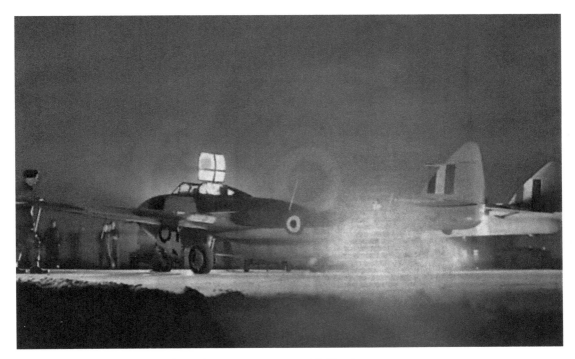

A Vampire NF10 night-fighter of 25 Sqn at RAF West Malling in 1952.

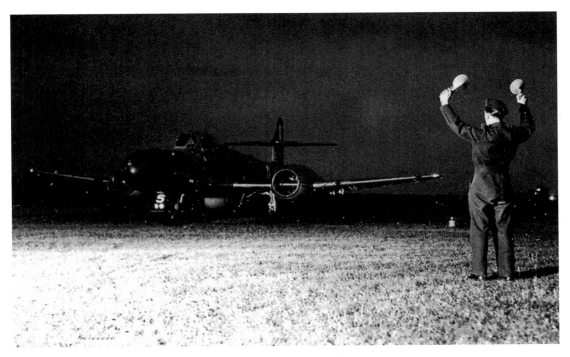

A Meteor NF14 of 85 Sqn being marshalled at RAF West Malling in 1954.

Momentum was just one of several similar air defence exercises that West Malling participated in during the 1950s and, with the arrival of 153 Squadron with its Meteor NF12s in February 1955, it soon became recognised as Britain's 'Premier Night Fighter Station'.

In 1957 RAF Fighter Command announced that West Malling would undergo extensive runway alterations to allow it to operate the latest Javelin fighters. The station was vacated and closed down when work began later that year on resurfacing the runway and perimeter track. Other improvements included the building of a combined Wing Ops/Flying Wing HQ and new married quarters for the officers and airmen.

The work was completed in 1958 and RAF West Malling was re-formed on 1 August that year. On 5 August 85 Squadron returned to the station flying its new Gloster Javelin FAW2 fighters.

Just two years later the RAF decided that West Malling was no longer viable as a front-line fighter station and deemed it surplus to their requirements. 85 Squadron left with their Javelins on 8 September 1960 and the station was handed over to the US Navy in a ceremony on 17 October. The *Kent Messenger* reported on the ceremony in its edition of 21 October:

The American Stars and Stripes and the Royal Air Force Ensign were raised simultaneously at the West Malling Air Station on Monday as the administrative control of the base was handed over to members of the United States Navy. At brief ceremonies in front of the headquarters building, Wing Commander F.N. Brinsden told the assembled officers and men to both the R.A.F. and American Navy that he was gratified by the goodwill, co-operation and patience shown by all concerned with the changeover.

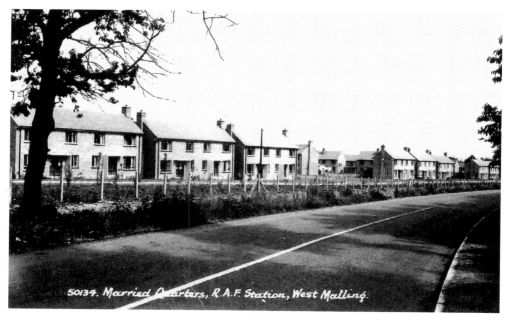

50134. Married Quarters, R.A.F. Station, West Malling.

The recently completed Airmen's Married Quarters *c.* 1960.

An 85 Sqn Gloster Javelin FAW2 on display at RAF West Malling in 1960.

Handing over RAF West Malling to the US Navy on 17 October 1960.

The American Naval Facility Flight at West Malling operated various aircraft in support of US ships serving in British waters. They stayed until 1967 when the airfield was handed back to the RAF only to be immediately placed under Care and Maintenance again. The facilities continued to be used by 618 Squadron RAF Volunteer Gliding Squadron who had arrived from Manston in 1965 and the aviation firm Short Brothers who had moved their servicing section there in 1964.

The airfield was bought by the Kent County Council in 1970 who wished to control its future development and in 1972 it was used to temporarily house Ugandan Asians who had been expelled from that country by its President, Idi Amin.

In mid-1983 the aircraft completion company METAIR moved in. They were engaged in the fitting out of private and executive aircraft to their customers' specifications. A year earlier the first 'Great Warbirds Air Display' took place at the airfield. The star of the show was a Boeing B-17 Flying Fortress bomber the 'Sally-B'. This aircraft had featured in a TV series *We'll Meet Again*. These shows continued every year until 1991. As well as the historical aircraft on display, the RAF also contributed displays by the Red Arrows, a Vulcan bomber and various Tornados, Buccaneers and Harriers. British Airways' Concordes also proved a popular attraction.

By the late 1980s KCC were looking for developers for the airfield site and chose the US company Rouse Associates to be their partner. The original plans were for a 'high-tech'

One of the former barrack blocks now used as commercial offices.

The former Sergeants' Mess in 2015.

business park with low-level industrial units and offices. Some residential development was also envisaged but the emphasis was put on the commercial usage plans with all its attendant benefits for local employment. However, the recession of the early 1990s saw the emphasis move away from the commercial to the residential development of the site. None of these plans included any continued use of the airfield for flying and by the mid-1990s METAIR and the Gliding School had left, and the runway demolished.

The site is now a major residential area, the parish of Kings Hill, with some offices, shops and leisure facilities. The old airfield domestic site remains almost intact with the barrack blocks and Sergeants' Mess being used as offices and the Officers' Mess in use by Tonbridge & Malling Borough Council and the police. The airfield control tower has been completely refurbished and turned into a coffee bar and offices. Most of the other airfield buildings have been demolished but some pillboxes, the remains of some shelters and a Bofors anti-aircraft gun tower can still be found on the outskirts of the site.

Royal Naval Auxiliary Service – Sheerness

As in previous wars, the major ports of the UK were considered to be primary targets for attack if the Cold War were to turn 'hot'. The ports were essential for the movement of troops to mainland Europe and maintaining the imports of armaments, food and raw materials that the country depended on. There was therefore an urgent need to respond to the Soviet threat to these ports and the shipping they contained.

On 5 November 1962, following the previous month's 'Cuban Missile Crisis', the Civil Lord of the Admiralty Ian Orr-Ewing announced in the House of Commons the establishment of the Royal Naval Auxiliary Service (RNXS), a uniformed, unarmed civilian volunteer service formed from the amalgamation of the Royal Naval Mine Watching Service (RNMWS) and the Admiralty Ferry Crew Association. The new service would be administered and financed by the Admiralty and would take over the existing responsibilities of the RNMWS for mine-watching duties and for providing the basic support staff for naval organisations installed in commercial ports of the United Kingdom in time of war. In addition, it would man, to the greatest possible extent, the naval organisation required in the country to control the movements of merchant ships in wartime. The RNXS would contribute to naval defence both directly by performing these duties and, indirectly, by releasing active Service ratings and reservists for first-line duties elsewhere.

Volunteers were recruited from all walks of life, many of whom were former RNMWS members and ex-servicemen.

Training Units were formed at coastal locations all around the UK including five in Kent: at Chatham, Dover, Gravesend, Margate and Sheerness. The Service was divided

Crests of the Royal Naval Mine Watchers Service and the Royal Naval Auxiliary Service.

into 'Afloat' and 'Ashore' sections. The 'Afloat' personnel manned the Service's dedicated ships and the 'Ashore' personnel manned the Port Headquarters (PHQ). RNXS volunteers, known as 'auxiliarymen' regardless of gender, were to be readily available to assist in the tasks of evacuating major ports and dispatching larger and faster merchant vessels overseas. The remaining ships, together with important port plant, were to be dispersed to safe anchorages along the coasts or in the islands. The sailing of merchantmen overseas involved setting up assembly anchorages where ships might be formed into convoys, a naval escort or surveillance arranged, and information provided on routing, intelligence and communications. Formation, planning and sailing of convoys were tasks undertaken in the PHQs by RNXS staff working within overall dedicated RN Reserve control during exercises. The Communications personnel operated the Communications Centre connected via teleprinter and, latterly computer, to all UK MOD Communications Nodes and, unassisted, performed these tasks solely within the RNXS structure on behalf of the overall PHQ Command and Naval Officer in Command (NOIC).

In the event of a possible nuclear conflict the RNXS 'Ashore' volunteers would man the Emergency Port Controls which would be accommodated in suitable 'hardened' bunkers. The Emergency Port Control for the Medway Estuary was located at the Victorian-era Garrison Point Fort at Sheerness. The fort was built in 1869 to protect the narrow entrance of the Medway between Garrison Point and the Isle of Grain 800 yards

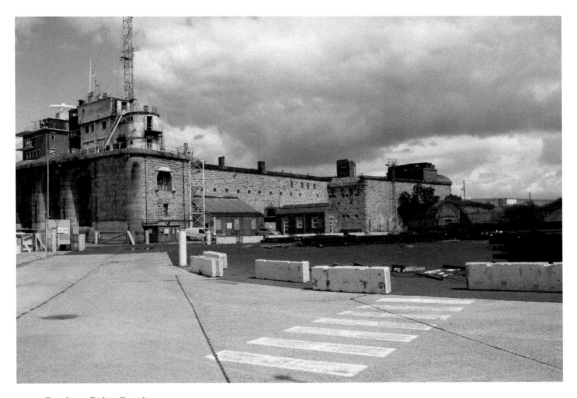

Garrison Point Fort in 2015.

away on the opposite side of the estuary. It was built as a two-tiered casemated fort of semicircular design, constructed from granite with iron shields to protect the guns in their casemates. On completion the fort was armed with thirty-six 9-inch RML guns housed on its two gun floors.

The fort's armaments remodelled several times to keep up with the changes in artillery practices and technology. In the early twentieth century, the fort became an anchor point for a boom defence across the entrance of the Medway. The boom extended to its other fixing point at Grain Tower denying access to the river by enemy shipping in times of war.

By the outbreak of the First World War, most of the gun casemates had been converted into stores or accommodation and the armament reduced to just four guns mounted on the roof. In the Second World War two new gun emplacements and two new gun towers were added. The fort remained in service with the Army until 1956, when all the coastal artillery units were disbanded. With the closure of the royal dockyard at Sheerness in 1960, the whole site including the fort was transferred to the Medway Ports Authority.

In 1963, the newly established RNXS took over a section of the fort's lower casemates and the magazines below for conversion into the Medway Emergency Port Control. The facility was accessed from a door in a covered way off the parade ground. Just outside the door stood a small brick building which housed the bunker's stand-by generator. The door opens directly into one of the converted gun casemates which housed an office, the galley

Converted gun casemate in 2006. (Photo: Barry Stewart)

and a canteen/restroom. An adjoining gun casemate was converted into male and female toilets and another casemate was used as the filter room for the ventilation system.

From the gun casemate level, a stone staircase leads down to the magazine-level passageway. Here, two of the Victorian magazines were converted into the emergency control room bunker consisting of several rooms including the control room itself,

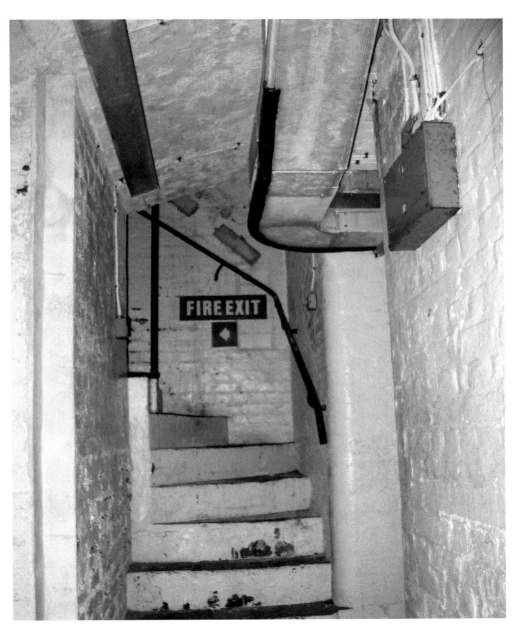

Stairs down to the magazine level. (Photo: Barry Stewart)

an armoury, staff officers' room, workshop, training room and communications rooms. Access to the other original magazines on this lever was blocked off.

With the end of the Cold War the future of the RNXS was soon called into doubt. During the early 1990s, the Royal Navy undertook a review of the continuing need for those tasks performed by its Reserve services, including the RNXS, and concluded that the scale and immediacy of a perceived threat to the western alliance had reduced to such an extent that it was no longer sensible to earmark specific forces for them. The end of that requirement removed the need for all but 135 of the RNXS auxiliarymen. After a careful study it was concluded that there were no other roles that would he suitable for the RNXS and that such a service of 135 would be too small to be viable. On 17 June 1993, the Secretary of State for Defence, Sir Malcolm Rifkind, announced to the House of Commons that the RNXS and its training units would be disbanded.

The final confirmation of the disbandment was announced on 18 February 1994 and the Sheerness bunker was then decommissioned and cleared. Garrison Point Fort remains part of Sheerness Docks and is not accessible to the public.

Converted magazine. (Photo: Barry Stewart)

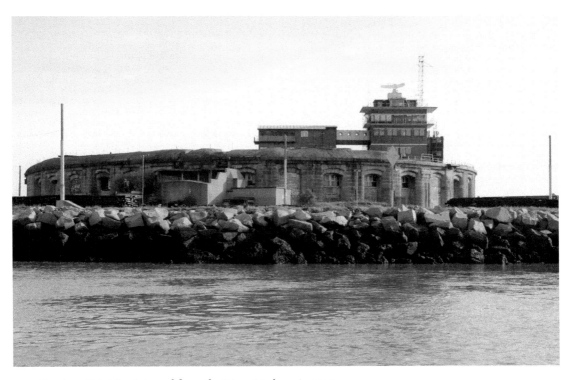

Garrison Point Fort viewed from the River Medway in 2015.

Bibliography

Brooks, R., *From Moths to Merlins* (Meresborough Books, 1987)
Campbell, D., *War Plan UK* (Paladin, 2015)
Cockcroft, W. and R. Thomas *Cold War* (English Heritage, 2004)
Dalton, M., *The Royal Observer Corps Underground Monitoring Posts* (Folly Books, 2017)
Hall, P., *By Day and By Night* (Foxed & Bound, 1988)
Hennessey, P., *The Secret State* (Penguin Books, 2010)
McCamley, M., *Cold War Secret Nuclear Bunkers* (Leo Cooper, 2002)
Moor, A., *RAF West Malling* (Pen & Sword, 2019)

National Archives Sources
ADM 1/11119 Combined Defence Operational Headquarters 1937–41
ADM 1/10956 Chatham Area Combined Headquarters Estimate of Costs
ADM 1/28651 Name of Headquarters, Chatham Reserve Unit 1963–64
ADM 1/16263 Admiralty Administration Combined Operations and Naval Stations

Internet Resources
Chatham Dockyard Historical Society: dockmus.btck.co.uk
Civil Defence Project: thetimechamber.co.uk/beta/sites/military/civil-defence-project
Cold War Civil Communications: ringbell.co.uk/ukwmo/index.htm
Hansard: hansard.parliament.uk/
National Archives: nationalarchives.gov.uk
Subterranea Britannica: subbrit.org.uk
Wikipedia: wikipedia.org